PAINTING
FIGURES &
ANIMALS
WITH CONFIDENCE

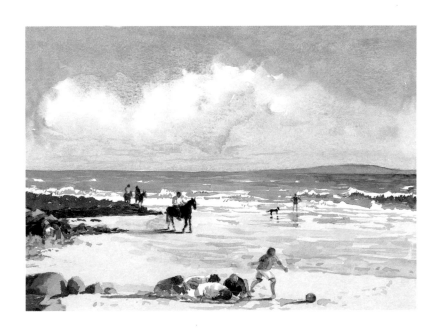

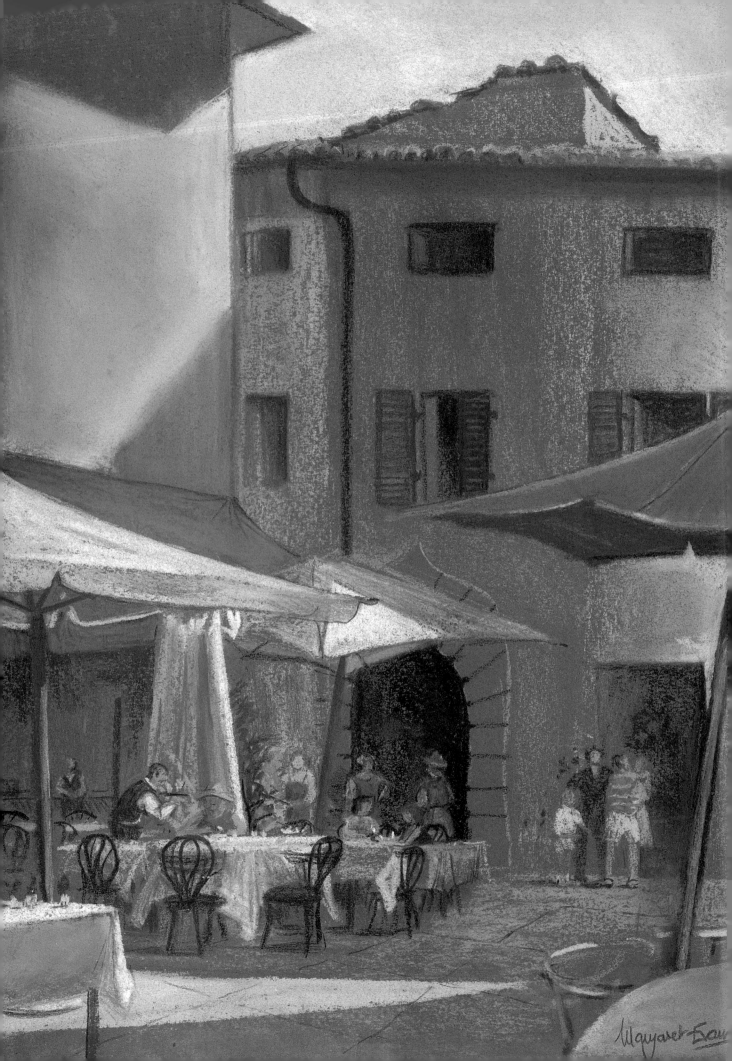

PAINTING
FIGURES &
ANIMALS
WITH CONFIDENCE

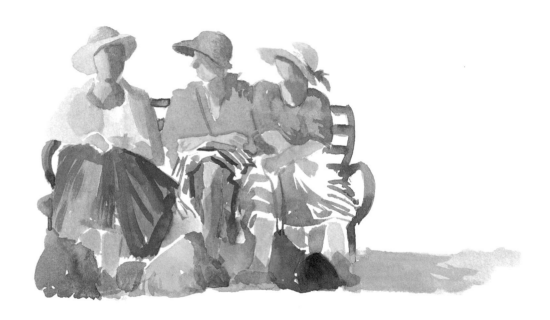

Margaret Evans

David & Charles

To the memory of my Dad,
from whom my love of art was born,
and to my husband Malcolm for helping me keep it alive.

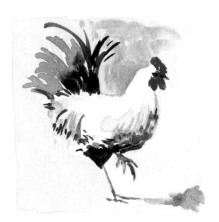

ACKNOWLEDGEMENTS
My sincere thanks to everyone who encouraged me as a first-time author, and helped me through the
many stages that are involved in producing a book, especially Sue Seddon, Susanne Haines, Freya
Dangerfield, Kay Ball and all the team at David & Charles; to Winsor & Newton for providing me
with all the excellent materials to paint with; to John and Richard Hope-Hawkins at Teaching Art
for all their encouragement and promotion, to my lovely students who inspired many of the artworks
included in this book, and most of all to my husband and family for believing in me.

A DAVID & CHARLES BOOK

First published in the UK in 1999
Reprinted 2000

A catalogue record for this book is available from the British Library.

ISBN 0 7153 0921 8

Designed by Diana Knapp

Printed in France by Imprimerie Pollina S.A.
for David & Charles
Brunel House Newton Abbot Devon

CONTENTS

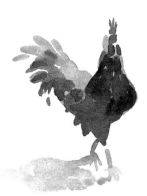

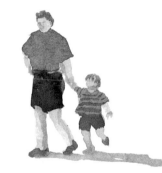

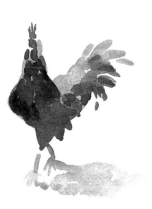

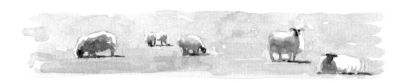

INTRODUCTION

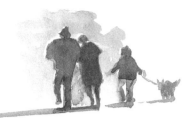

FOR MANY ARTISTS, the thought of putting figures and animals into landscape painting is daunting. However, there are some simple techniques that you can use to produce convincing figures and animals, thus adding life and interest to your landscapes.

My aim is to help you gain in confidence as you work through the book. The chapters guide you in easy stages through the different aspects of painting figures and animals, identifying and overcoming the problems that people encounter when incorporating them in a setting. They lead you progressively closer to the subject, from simple distant forms in landscapes, through figure compositions in closer settings, to tackling portraits for the first time.

Using various mediums, including watercolour, pen and wash, pastel and oils, the techniques shown on these pages will help you to build your confidence and create convincing life in your paintings.

I begin with the sketchbook. These personal 'diaries' of what interests you as an artist are important for building confidence because you can keep them private. In them, you can build up a record of what catches your eye, discover your strengths and weaknesses, and experiment without fear of criticism.

In Chapter Two the main aim is to simplify the process of recording people and animals. Techniques and exercises show you how to see forms as simple shapes, use tone to make the subject look solid and lifelike, create movement and add distant figures and animals into a landscape.

The vast range of commercially available colours can confuse beginners, so I have simplified the palette to seven colours. This basic palette still gives versatility, but reduces the number of decisions to be made.

Planning a composition and using tone to advantage are discussed in Chapters Three and Four. At the end of each chapter, there is a demonstration painting using the techniques and points covered.

The book is planned to present new challenges and show you how to approach them as you gain confidence. These challenges include capturing movement and gestures, and the way in which people interact when in groups. By this stage, you will have progressed from sketching simple stick figures and basic animal forms to painting full-scale figures and animals seen close enough to distinguish facial expressions. The final two chapters introduce simple methods of tackling human and animal portraits.

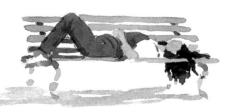

Whether you work in watercolour, acrylics, pastels or oils, I hope this book will encourage you to populate your paintings. I wrote it to inspire confidence and show that it is not necessary to paint figures and animals in great detail, or to have a detailed knowledge of anatomy, in order to bring life to your landscapes.

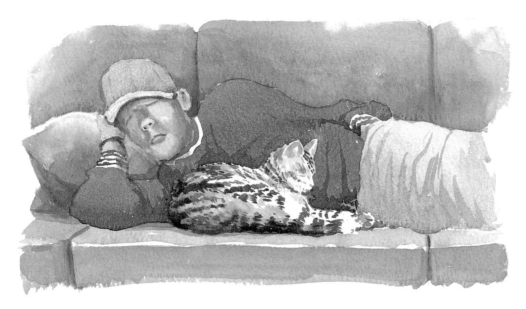

A watercolour study of my son Matt and the cat snoozing on the sofa.

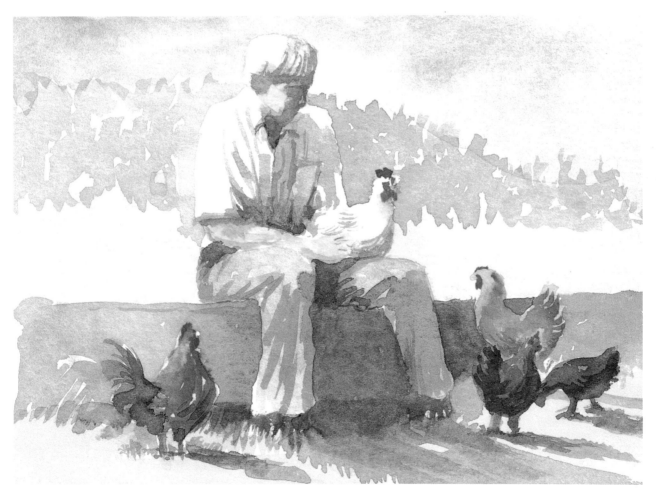

A watercolour sketch of Malcolm, my husband, with some of the hens that wander freely round my studio shows the importance of keeping the scale between animals and humans accurate. The background is understated to keep the emphasis on the figure and hens.

CHAPTER ONE

WORKING WITH A SKETCHBOOK

Your sketchbook should be your constant companion. In it you can, without criticism, sketch what catches your eye. Whatever the style or medium, it is the place to practise, and where your confidence will grow.

Think of your sketchbook as a kind of diary. It is for private use and not for public viewing. It is where you can doodle with ideas and play around with composition and colour. Not everything you do in a sketchbook will be successful; indeed, many ideas never go beyond the first stage and are relegated to failure. But success can come of failure if such ideas are tackled in a different way and then developed. Many beginners are afraid to add figures or animals to their compositions for fear of spoiling the picture, while others rely on copying photographs or pictures from magazines. But by using a sketchbook all the time, you can overcome inhibitions, and original ideas can take shape.

A sketchbook is not the place to paint or draw polite little pictures. Instead, reject detailed and fussy work and use it to develop a style of working that is free. With that freedom comes spontaneity and, hopefully, from that will come successful paintings.

These sketches are done in a sepia waterproof ink using a fibre-tip pen. They were sketched quickly while the subjects were unaware they were being observed.

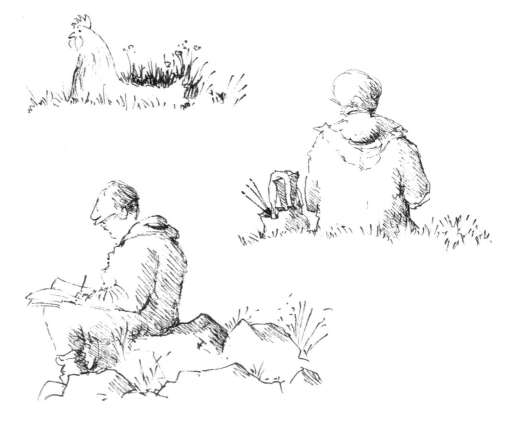

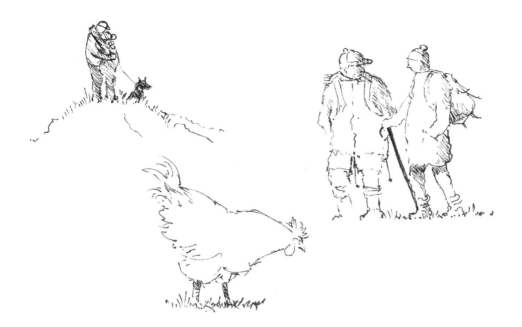

IDENTIFYING PROBLEMS

Many people avoid painting figures and animals because they think they are too difficult to do. If you have never used a sketchbook before, start with your favourite subjects and doodle away in the medium with which you feel most at ease – whether pen, pastel, pencil or paint. It is important to be able to identify the weaknesses in your work so that through the desire to improve you can make progress.

Common problems are inaccurate colour mixing; a difficulty with tonal value, which leaves everything looking flat; and a lack of knowledge and understanding of the underlying structure of the subject. However, failures in the sketchbook bring about a desire for improvement. We all know that practise makes perfect so it is important to keep the sketchbook going, and not be afraid to try different approaches. And remember, don't be afraid of failure – it's only a piece of paper.

SUCCESSES AND FAILURES FROM THE SKETCHBOOK:

The first hen was completely wrong in shape, and looked like a cross between a hen, a duck and a turkey! I wrote as much against the original sketch in the sketchbook.

When working rapidly to capture movement you may end up with a figure that has no shape or proportion. With the 'stick' method of checking proportions (see page 16) the figures will start to look more lifelike.

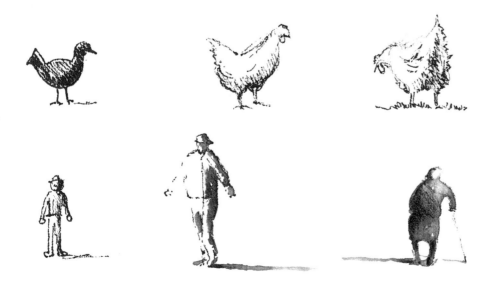

SKETCHBOOK MATERIAL

TIP

Which type of paper should your sketchbook contain? Good watercolour paper of 300gsm (140lbs) minimum is best. 'Not' surface is good because it is slightly textured – not too rough and not too smooth.

Your sketchbooks are the place where ideas for subjects to paint should originate. This does not mean you cannot use photography as an additional source, but if you are to develop your powers of observation there is no substitute for sketching from life. Copying photographs is not enough.

From the ideas in your sketchbook, try developing several options into a composition, moving things around, changing the focal points, or even merging ideas from several photographs into one sketch. It is also important to get into the habit of sketching (or even doodling) in a notebook wherever you go, no matter how little time you have. I prefer an A4 sketchbook as I can get several sketches on one page, but an A6 sketchbook will slip into a pocket with a pencil or pen.

Try a few pencil sketches first and resist the temptation to rub out: the freedom of several lines gives an even sketchier appearance to the work. Next try some pens. Those with waterproof ink are fine, but you may want to try water-soluble ink, which gives a lovely wash effect when diluted with a damp brush. You could ease yourself into colour by trying pen and wash with just a tint of colour, and from this move into full watercolour or pastel. Pastel inspires confidence as it can be erased, and is available in thin or thick sticks as well as pencil forms. Then you can progress to one of the miniature pocket paint boxes on the market.

On holidays, or on painting trips, I encourage students to build up a sketchbook diary of daily events, rather than creating finished paintings each day. You can always write in your colour notes for later paintings. By filling sketchbook diaries with studies, paintings and anecdotes of incidents, you will create a fascinating travelogue in no time.

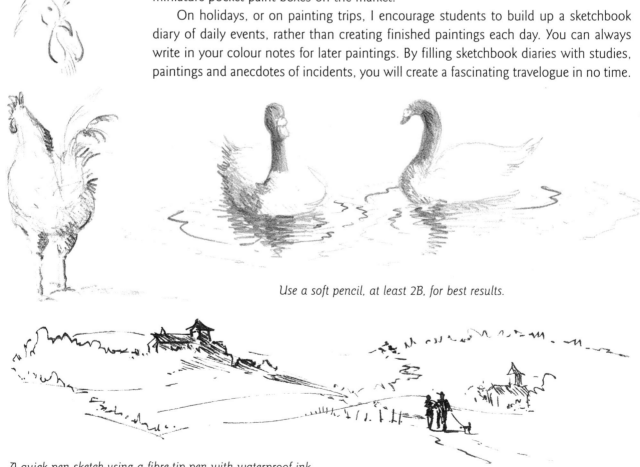

Use a soft pencil, at least 2B, for best results.

A quick pen sketch using a fibre-tip pen with waterproof ink.

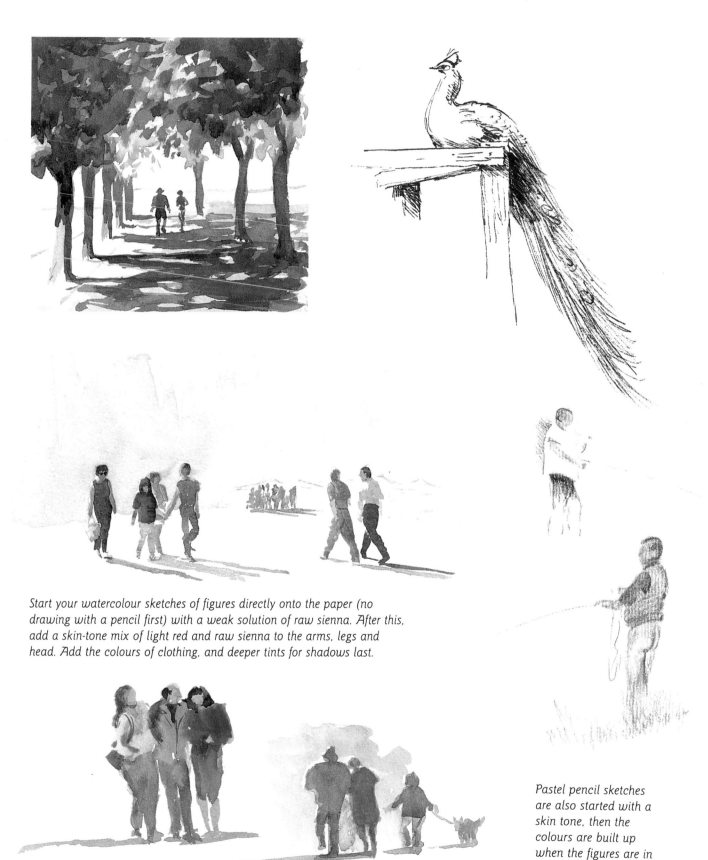

Start your watercolour sketches of figures directly onto the paper (no drawing with a pencil first) with a weak solution of raw sienna. After this, add a skin-tone mix of light red and raw sienna to the arms, legs and head. Add the colours of clothing, and deeper tints for shadows last.

Pastel pencil sketches are also started with a skin tone, then the colours are built up when the figures are in position.

PRACTISING DRAWING SKILLS

Everyone can relate to a pencil, as we have all used them since childhood. Perhaps that is why it is the most popular tool for a beginner faced with the daunting prospect of art classes. If you start with lead pencils and explore the differences between hard and soft leads you will soon discover that a greater variety of marks can be made with soft leads. Using a 2B pencil, which is relatively soft, you can build up areas of different tonal values (see Chapter Four), which will create the illusion of depth.

At first, animals may seem impossible to sketch because they are always moving. If you observe them carefully and try to equate each animal with a geometric shape (see page 18), sketching them will begin to get easier.

Keep your pencil sketches loose and free, and try not to get bogged down in detail. Aim to capture the overall character and essence of the subject rather than to create a perfect, finished drawing.

A soft lead combined with a slightly textured paper will give a grainy effect and help to create tone.

MOVING INTO COLOUR

Once you have developed your drawing skills a little, you can move on to colour. Your first attempts at sketching in colour can be simple washes to enhance a drawing, or sketching with pastel pencils. As you progress through the book, you will see that colour can range from soft and minimal, to bold and beautiful. I find that a palette of limited colour is helpful as it eliminates much of the decision making that a vast range of colours brings. With some help in choosing limited palettes (see page 26) you will be able to develop your figures and animals in a variety of mediums.

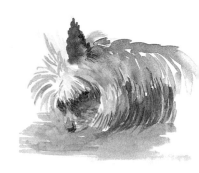

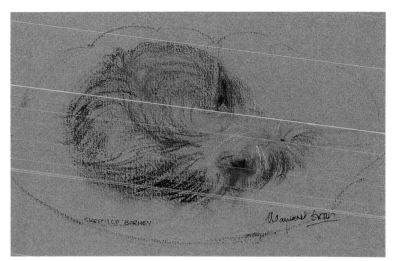

The pastel and watercolour sketches of my Yorkie, Barney, are done very fast from life. Each sketch takes between 10 and 15 minutes to execute, but this does not include observation time. Sketches are a good way to keep your drawings free and spontaneous.

The pastel life study of Anna, my Great Dane took about 40 minutes using soft pastels. When working with animals, time is limited to the availability of the subject, but you can start with 10-minute pencil sketches, like those of Anna opposite, and build up to more detailed sketches.

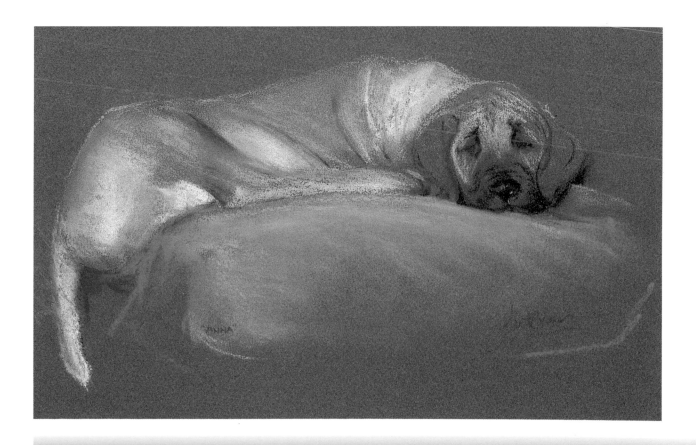

FRENCH FARM SCENE

Using photographs and sketches, you can put together a composition to paint in your preferred medium. For this scene, I took photographs and made sketches of a French farmhouse, then combined them in a composition that I will use as reference for a painting later.

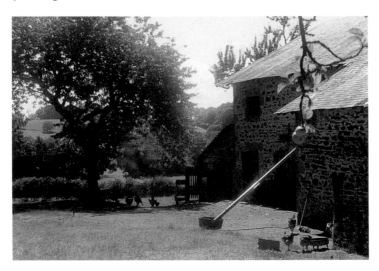

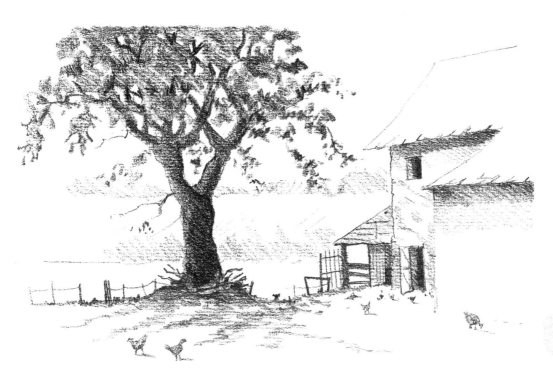

The black and white sketch was done on the spot. I included the main features and left out unnecessary detail.

The final composition. The hens are now better placed than in the preliminary sketch. I also thought it would be interesting to have a few farm workers feeding the hens. Using a pen with black, water-soluble ink, I sketched in the basic composition, then washed the drawing with a damp brush, using the soluble line to create shadows. This also fixes the ink before adding colour tints. I added the colours but kept them pale, as this is initially a pen study with a hint of wash. I then add the hens and figures, and any further line work, such as gates and posts, needed to provide interesting detail. I have made subtle changes from my original sketch and can use the best parts when working on a painting of the subject.

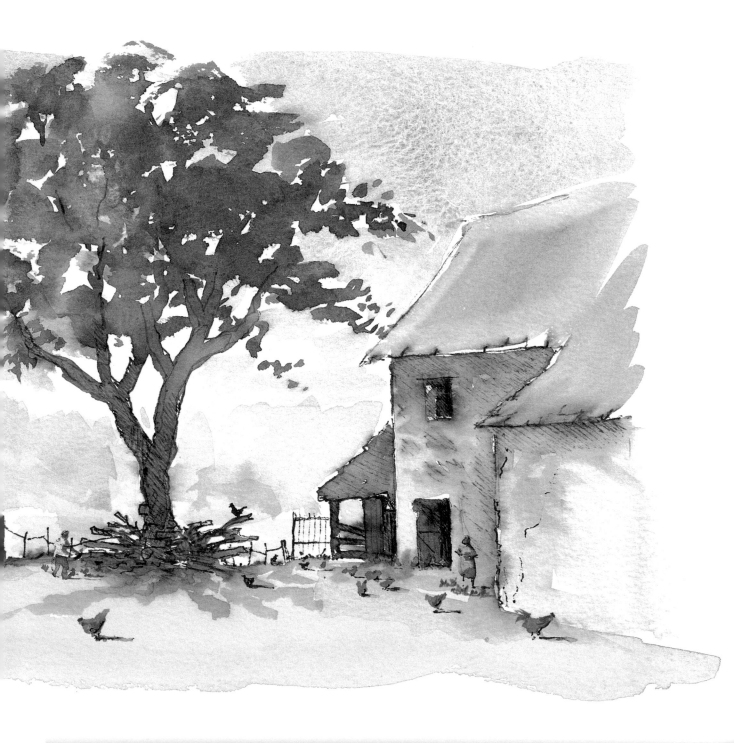

CHAPTER TWO

SIMPLIFICATION

ANY FEAR OF DRAWING FIGURES AND ANIMALS CAN BE OVERCOME
BY KEEPING THINGS SIMPLE, AND BY PLENTY OF PRACTICE. START BY
SIMPLIFYING SHAPE, COLOUR AND TONE, AND MAKE QUITE SMALL,
DISTANT AND GENERALISED DRAWINGS OF YOUR SUBJECTS.

STICK PEOPLE

Beginners to painting and drawing often joke that their figures look like stick people, but you can turn this to your advantage by developing the shape of a figure from a stick – it will soon start to resemble a little person.

For a standing figure, draw a stick to represent the height, then mark it off at intervals (as in Fig 1) for the main divisions of the body. This will help you to establish the general position of the body and some of the proportions, such as the size of the head. (An adult head is approximately one-eighth of a person's height standing straight – much smaller than most people imagine.)

Now you can build up areas with pencil or hatching, or a brushstroke, to represent the main shapes of the head and torso, and add arms and legs. (I used a 2B pencil on cartridge paper.) The magic happens when you put in a mark to represent a shadow – it instantly anchors the figure to the ground and gives it a sense of three-dimensional form.

You can apply this approach to figures in many different positions. Try a variation, such as an old lady bent over her walking stick, as in Fig 2. Then build up a collection of figures, varying the posture, clothing, shapes and characters. When drawing children, notice that, in proportion to the body, the head is larger than that of an adult.

The stick method is a wonderful introduction to drawing figures, and once you have practised, a quiet confidence will emerge and the figures become great fun to draw.

FIG 1
Start by drawing a line about 5cm (2in) long. Divide the line in half, then into quarters. Divide the top quarter in half, to give two eighths. Draw the head in the top eighth; below it make a horizontal line for the shoulders, then block in the body, tapering it towards the halfway point. Continue down, making a skirt, Use the stick for one leg, (or thicken it to represent trousers). Add another leg and arms.

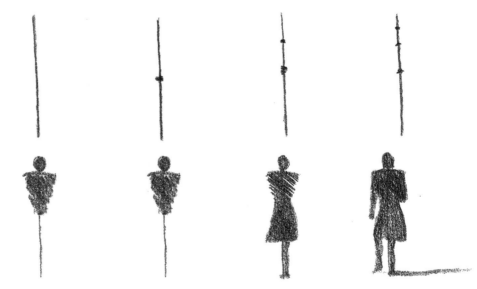

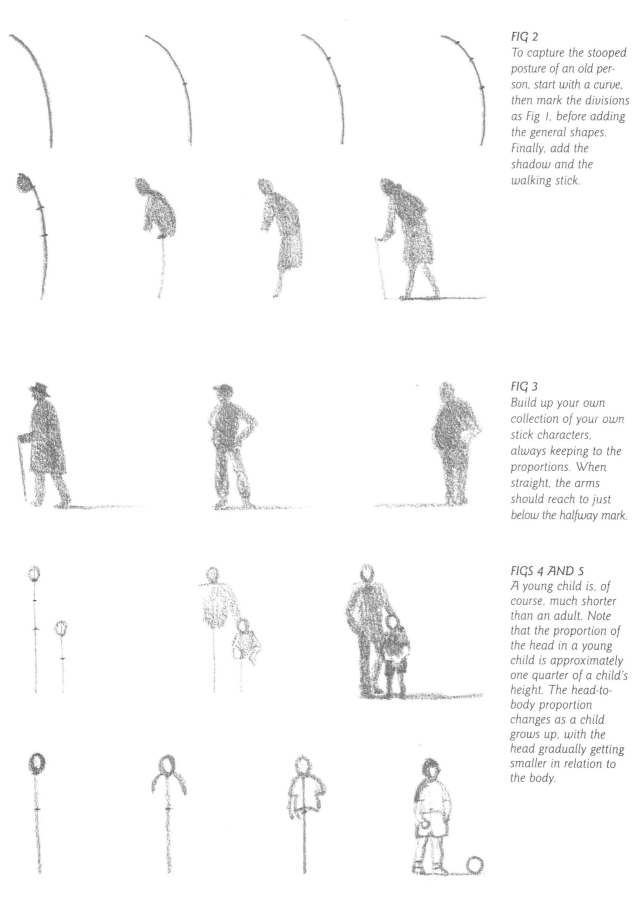

FIG 2
To capture the stooped posture of an old person, start with a curve, then mark the divisions as Fig 1, before adding the general shapes. Finally, add the shadow and the walking stick.

FIG 3
Build up your own collection of your own stick characters, always keeping to the proportions. When straight, the arms should reach to just below the halfway mark.

FIGS 4 AND 5
A young child is, of course, much shorter than an adult. Note that the proportion of the head in a young child is approximately one quarter of a child's height. The head-to-body proportion changes as a child grows up, with the head gradually getting smaller in relation to the body.

GEOMETRIC SHAPES FOR ANIMALS

There is a simple starting point for drawing and painting animals that is as effective as the 'stick' method for figures. The approach I adopt is to use a geometric shape as a simple form on which to base the overall shape of the animal: for instance, an oval for the body of a sheep, a circle for a hen, a triangle for a cockerel, and a rectangle for a cow.

Once the basic geometric form is on the paper, legs, heads and tails can be positioned on the general shape. Confident that all the parts are in the correct relation to one another, you can then go on to work up the details.

The basic shape of an animal will vary according to its position. For example, the side view of a sheep may be more of a rectangle than the oval shape of the front or rear views.

SHEEP REAR
The rear view of a sheep begins with an oval, to which legs are added. Decide on the position of the light source and add tone. Add the head, then anchor the sheep to the ground with a shadow.

SHEEP FRONT
In the front view of a sheep, the head is a small triangle that cuts into the oval body. The addition of some tone helps to give the animal a three-dimensional air.

HEN
A hen is based on a round form with triangles for the head and neck, the tail, and the thighs. Keep the lines fluid and sketchy to create the illusion of feathers.

COCKEREL
The cockerel is based on a triangle. Tone is covered in detail in Chapter Four, but if you add a few hatched lines to indicate the darkest parts, the animal will begin to come to life.

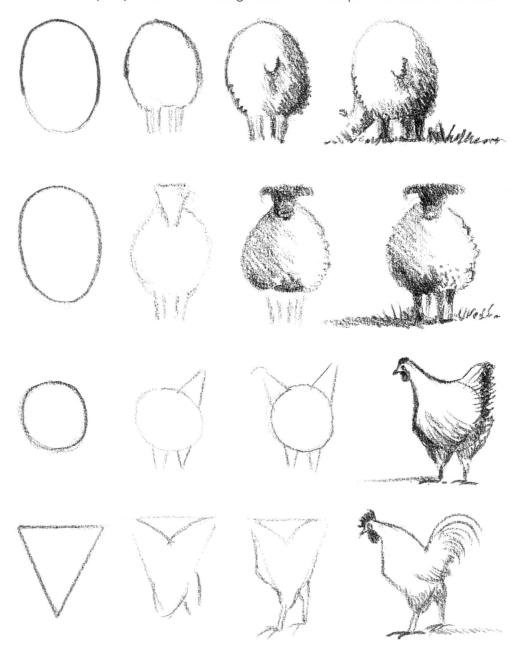

TIP

To see the geometric shape in an animal, half close your eyes and study the subject carefully. Try to see it as a simple shape – an oval, triangle, circle, etc. This is sometimes easier if you imagine that you are drawing a line around the subject.

PECKING HEN

A differently shaped triangle is used to draw a chicken pecking food from the ground. Keep the legs short and the head small. Neck feathers are suggested with a few simple lines.

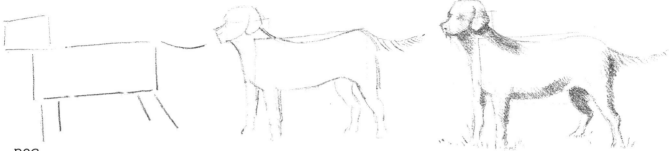

DOG

The dog's head and body are rectangles. Note how the back legs slope and how the most solid tone suggests the deepest shadows on the animal, especially on the back leg.

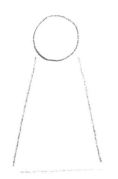
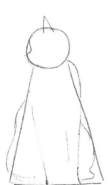
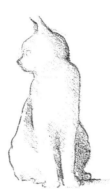

CAT

A triangle and a circle are the simple base for a seated cat. The circle of the head cuts off the point of the triangle so that it really looks joined to the body and not perched awkwardly on top.

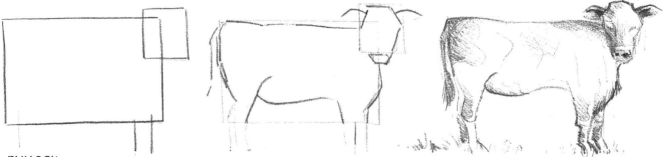

BULLOCK

Cows and bullocks are angular animals and can be based on a rectangle.

FILLING OUT THE FIGURE

Geometric shapes can also be used to understand how to draw the human figure. Unlike the animals on pages 18 and 19, the human figure is not contained within one shape but is built up from a number of ovals and circles.

By drawing the figure in sections I can take into account the joints in the arms, legs, and hips, etc. I find this simplification particularly helpful when trying to capture movement (see Chapter Five), especially if I do not have a model to observe, as I can try out the figure in all sorts of positions. If you find it difficult to imagine the way a human being articulates, a wooden mannikin is useful, although expensive, to draw from.

FIG 1
A simple standing figure is built up from ovals, triangles and circles. The proportions are the same as for stick men: the adult head is one eighth of the rest of the figure.

FIG 2
Once you are happy with the figure's posture it can be worked up into a clothed figure. This type of figure can be developed into numerous action poses easily. Remember, if you are going to clothe it, don't draw the mannikin in too heavily to start with.

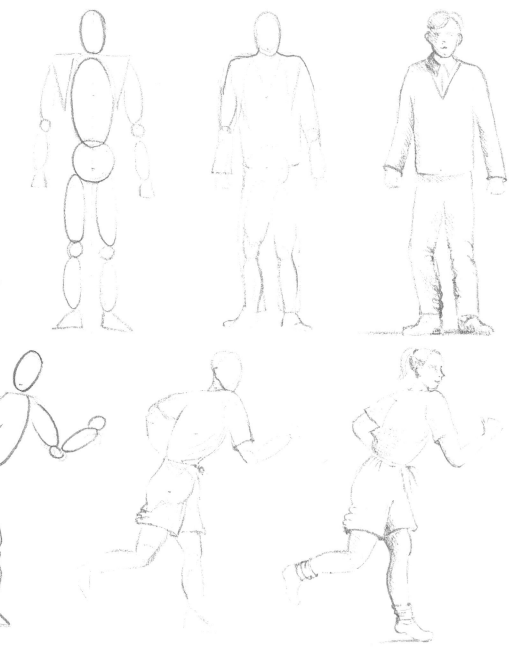

BASIC WATERCOLOUR FIGURES

Start with basic watercolour figures and build up your confidence gradually. Small figures and general back views are not as intimidating as detailed figures. The simple technique of building up is seen in Fig 3, starting with a weak watercolour wash of skin colour.

In Fig 4 the figure is combined with the suggestion of a setting. Seen dark against a shaft of light, the figure is lightly blocked in with a skin colour as a whole shape, then built up with stronger colours to create maximum impact against the light.

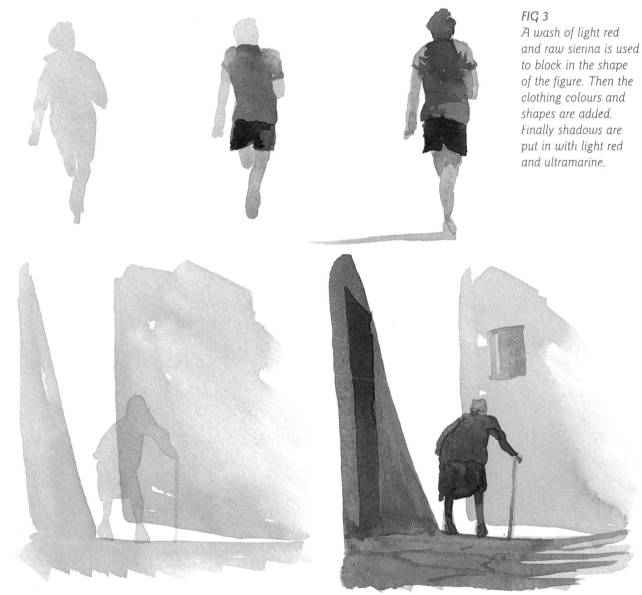

FIG 3
A wash of light red and raw sienna is used to block in the shape of the figure. Then the clothing colours and shapes are added. Finally shadows are put in with light red and ultramarine.

FIG 4
The positions of buildings and figure are lightly blocked in with a watercolour wash.

Stronger colours are added for shadows. Although the figure is not detailed it is clearly an old woman.

DEVELOPING TONAL VALUE

Objects in the real world look solid and three-dimensional because of the way light strikes them, creating a lit side and a side in shadow. By adding shading, or tone, to your figures and animals you can create the illusion of solidity (see Chapter Four). Start by adding shading in the simple exercises you have already done. To keep detail to a minimum, deal with figures and animals in an informal way either in the far or middle distance.

Use your pencil to shade the dark tones with hatched or blended marks and doodles, working in your sketchbook. Start by adding tone to a stick figure. Decide where the light is coming from and add a cast shadow. I think the cast shadow should be included as soon as you place anything – whether it is a figure, animal, tree or building – if it is added later it can unbalance the entire composition.

Build up animals from geometric shapes, and add shadows to these drawings. Remember to keep the shadows consistent. If you make the drawings simple and loose, and don't try to tidy them up, they will keep their spontaneity.

Draw an arrow to remind yourself where the light is coming from and put shadows on the opposite side of the figure. Make the shadow with hatched and blended marks and doodles.

The cast shadow on the ground is particularly important as it anchors the figure to the ground. Resist the temptation to add detail at this stage.

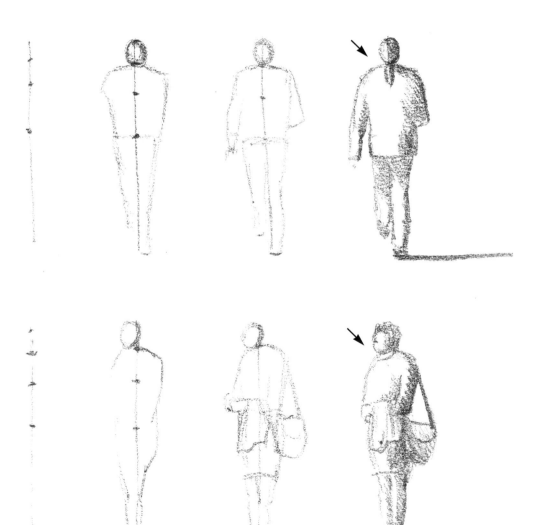

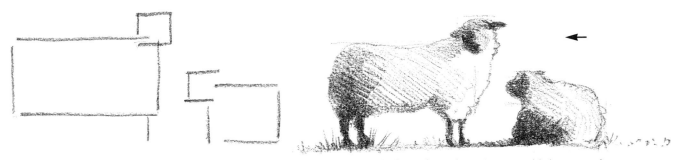

Simplify an animal to a few basic geometric shapes and build up the body forms from these. Again, add the arrow for direction of light, then add shadows.

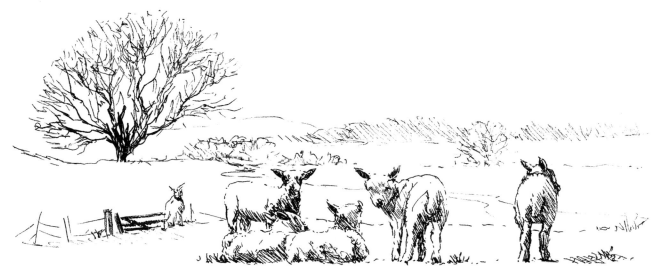

As your confidence grows you can work in different media. These lambs were sketched in pen. The light is coming from the left and the simple hatching indicates the areas of shadow.

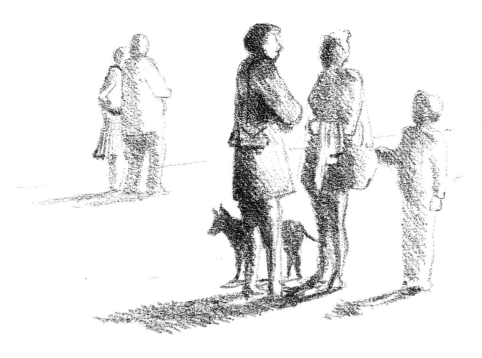

A sketchbook full of stick figures with animals based on geometric shapes with added tone, built up to create little groupings is an invaluable source of material when you want to add life to a painting.

TONAL SKETCHES

A quick sketch from life can be greatly improved by studying carefully the direction from which light is falling, and then adding shadows to suggest three-dimensional form.

When time is limited and you need to do a quick sketch to capture crucial information, you can use a mid-tone paper. Mid-tone papers are available in a range of tones from pale papers to rich, strong dark colours; they can be any colour, such as blues, greens, beiges or pinks. They are great for quick sketches as the paper provides the mid-tones, making the process of simplifying tones into clear divisions of light, medium and dark a much easier process. Use a soft pencil and a white crayon to draw in the subject. Then build up the lighter areas and deepen the shadow areas to suggest light and shade.

A little tone is shaded in under the body of this bullock to give depth to the shape. Thankfully, cattle don't move too fast, and tend to be curious of artists, watching our every move with quiet indignation.

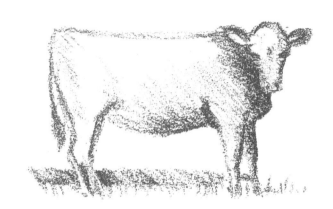

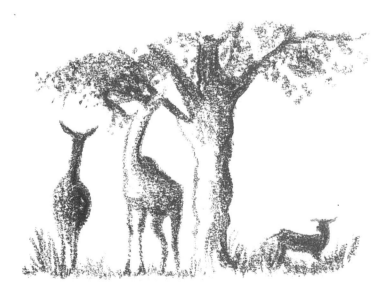

Tone is used here more dramatically to silhouette the deer against the bright sky. I only had a few moments to capture the animals as they grazed on a grassy bank until they became aware that I was watching them. Sketchbooks should be full of spontaneous glimpses like this – even if they are sometimes unsuccessful.

OPPOSITE
The simple light and dark tones on the mid-tone paper give the figures a sense of form and imply the fall of light. These sketchbook studies were made in Tuscany, but they could have been built up from the imagination by working out the poses using the mannikin method (see page 20).

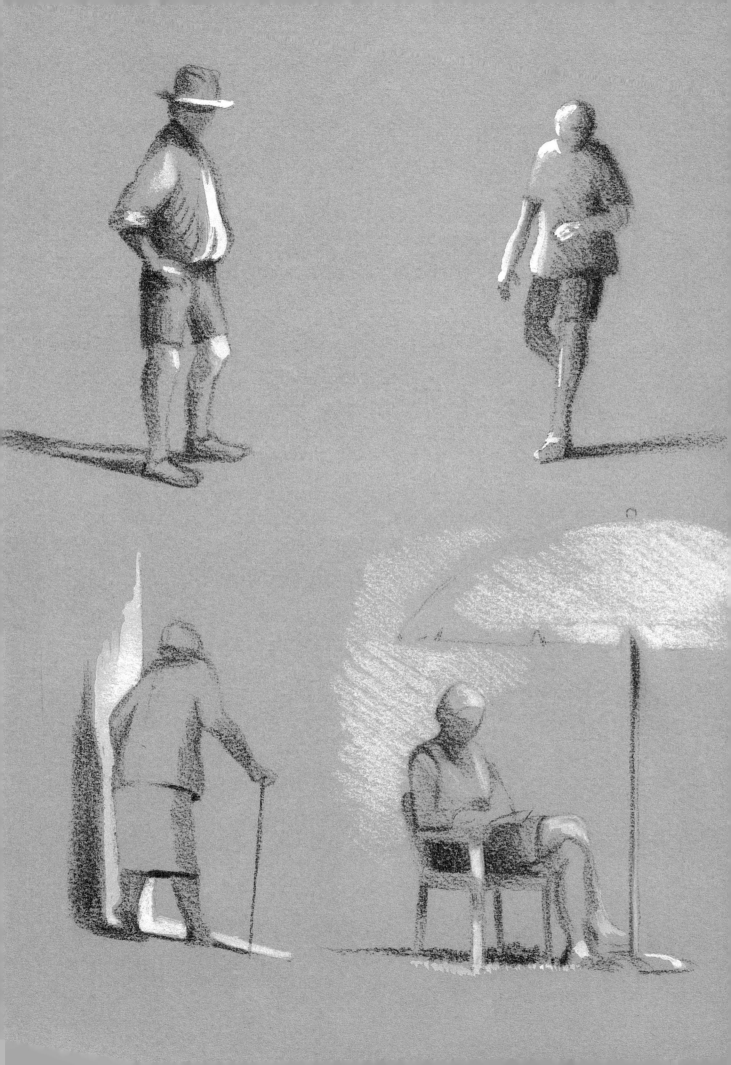

KEEPING COLOUR SIMPLE

Life is made simpler by cutting down the amount of decisions you have to make, and this is where a limited palette of colours will not only lessen the confusion, but make you mix colours more. Each colour therefore works harder, and justifies its value, and your paintings will have more unity because of the limited choice.

I teach with a basic palette of seven colours, which I think are essential. Others can be added as your confidence grows, or the need arises, especially if you paint abroad. I use the same seven colours whether I work in watercolour, gouache, oils or acrylics.

THE BASIC PALETTE

LEMON YELLOW/WINSOR YELLOW
This must be a true, lemon yellow, as opposed to a weak, opaque yellow, or deeper cadmium.

RAW SIENNA
More transparent than yellow ochre, therefore better in watercolour, although both can be used: raw sienna for transparent, distant washes, and yellow ochre for layers in the foreground.

BURNT UMBER
A dark brown, which is essential for making really dark greys/blacks. Starter kits often do not include burnt umber, but include instead burnt sienna, which does not have sufficient tonal depth.

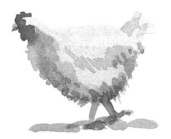

The 'white' chicken is built up from a simple shape made in a pale watercolour wash of lemon yellow. The wattle and comb are suggested with a little alizarin crimson, and the legs and shadow are added with burnt umber. Try this simple painting of a hen. It is an excellent way to overcome the fear of painting directly onto paper.

ALIZARIN CRIMSON

A good, all-round red that mixes well with blue to make purples, mauves and violets. It can also be added to yellow to make oranges and bright reds.

LIGHT RED

Although more opaque than burnt sienna, this lovely, terracotta type of colour is invaluable for mixing with ultramarine to make a purplish-grey that is useful for many things, including cloud shadows, distant mountains, French roofs and Tuscan skies.

FRENCH ULTRAMARINE

The hardest-working colour in the basic palette. With yellows it makes green; with burnt umber it makes a range of blacks and greys (which are more exciting than Payne's gray); with red it makes purples, lilacs, pinks and mauves; and on its own it looks great in skies, even when it granulates to give a lovely out-of-control effect.

PRUSSIAN BLUE/WINSOR BLUE

An indulgence I could not do without. It makes such delicious dark greens instantly, that it is too good to miss.

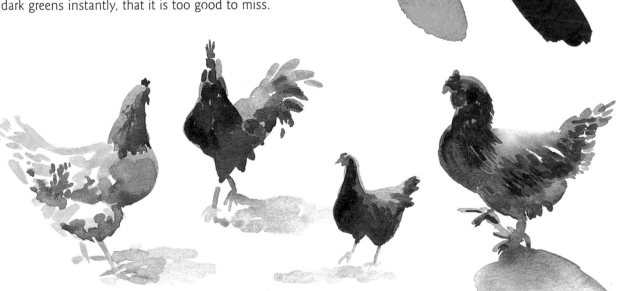

The dark cockerel and hen were built up with increasingly stronger washes of ultramarine, with a hint of light red on the chest to add form. The brown hens were based on raw sienna and light red.

IMPORTANT COLOUR MIXES FROM THE BASIC PALETTE

Two colours can be mixed in different proportions to produce a range of colours in between. To broaden your scope, experiment with mixing but use small amounts of each colour until you are more confident. The colours are affected by the amount of water, turps, or other mixing medium that you use. When working in watercolour I always dry my brush off between mixes as too much water will dilute colours too much. Acrylics are versatile and can be mixed thickly, and with white, like oils; or you can mix them thinly like watercolours, omitting white from the palette for maximum transparency.

Start with lemon yellow and add touches of alizarin crimson to create colours similar to cadmium yellow, cadmium orange and cadmium red through to alizarin crimson.

Start with raw sienna and add touches of Prussian blue to create a range of greens. This can be also be done with ultramarine, which gives a different range of greens.

Start with burnt umber and add touches of ultramarine to neutralise the warmth of the brown and make it cooler. Halfway, this makes black and dilutes to greys, then moves into indigo, Payne's gray and blue.

Start with alizarin crimson and add touches of ultramarine to make mauves, pinks, and purples, then on to blue – ideal flower colours throughout.

Start with light red and add touches of ultramarine to make soft brown, then a purplish-grey for shadows, buildings, and clouds, then on into blue.

Start with Prussian blue and add burnt umber to make cool forest greens, through dark mossy greens into brown.

Start with ultramarine and add touches of lemon yellow to make cool greens for distant hills and trees, to warmer greens, right through to yellow.

TIP

When mixing a pale colour in oils or acrylics, start with white, or the palest colour, and add the stronger pigment to it until you achieve the colour you want.

OIL PALETTE

My basic palette for oils is similar to that of watercolours, but the main addition is white. It is always worth buying large tubes of white as it is used in such large quantities.

TITANIUM WHITE
Has the best consistency for mixing.

LEMON YELLOW
Makes good fresh greens when mixed with blue and good oranges when mixed with red.

RAW SIENNA OR YELLOW OCHRE
Although I prefer the transparency of raw sienna for watercolour, when added to white it is very similar to yellow ochre.

BURNT UMBER
Essential for making darks.

LIGHT RED
Produces delicious mixtures of purplish-grey when mixed with ultramarine, and has an additional range when mixed with white.

ALIZARIN CRIMSON
...or similar, such as rose madder. Both make fresh purples and mauves.

FRENCH ULTRAMARINE
Very important for many colour mixes including with yellows to make greens and brown to make black and greys.

PRUSSIAN BLUE
Mix with burnt umber for an instant dark green.

MIXING PASTELS

Pastels can also be mixed. If you take the seven colours of the basic palette (see page 26), plus white, the same mixtures can be made by adding colours on top of each other. Try it with a couple of primary colours, such as blue and yellow. Here, I have mixed ultramarine with Winsor yellow. This simple exercise proves that you can treat pastel exactly the same way as any other medium.

ultramarine

yellow on blue

blended

Winsor yellow

blue on yellow

blended

Putting blue on first, then yellow, makes a slightly different green from putting yellow first, then blue. This is because the first colour grips the tooth of the paper and tends to be thicker than the second colour. A more intense version of each can be made by blending both mixes with your finger. Try the exercise with red and yellow. Vary the order you use them to produce different shades of orange.

PASTEL ADDITIONS TO THE BASIC PALETTE

Although it is possible to create a basic palette in pastels, people are often tempted to buy a huge range of colours simply because they are, like sweets in a shop, so tempting. However, if, like me, you cannot resist so many colours there is a bonus: such a selection creates shortcuts. I have a weakness for greens that I would not tolerate in another medium as I prefer to mix my own.

Some of the colours I use to supplement my basic palette are shown here, either in the form of very soft pastels, or of hard pastels. The harder pastels are more limited in colour, but they are excellent for detailed work, such as adding figures and animals to landscapes. If, like me, you mix soft pastels with harder varieties, it would not be too indulgent to have both groups. You can add to the list as subjects, seasons and countries vary, but beware of adding just for the sake of it. Together with the seven basic colours, this is still a limited palette which you will find easy to carry when working out of doors.

The luxury of four greens is useful as they range from a bright, clear green, which can be lightened with white, yellow, or pale blue, to a soft woody tint, such as oxide of chromium, to the darkest green mixes you can find, such as pthalo green.

SOFT PASTELS

permanent sap green tint 4

permanent green light tint 3

oxide of chromium tint 5

olive green tint 4

HARD PASTELS

grey green

olive green

chromium oxide green

pthalo green

Five different shortcut colours, in either soft or hard pastel, offering a pale sky blue for quick blocking in, a few blue-greys, or indigo types, and pinky-greys, which are ideal for clouds and shadow. I frequently use the pale raw sienna tint for highlighting, as well as in skies.

SOFT PASTELS

French ultramarine tint 1

indanthrene blue tint 5

caput mortuum tint 5

caput mortuum tint 2

raw sienna tint 1

HARD PASTELS

sky blue

Payne's gray

red earth

flesh

Naples yellow

ADDING ANIMALS TO LANDSCAPES

'I wish I knew how to add animals to my landscapes,' is a cry I frequently hear from my students, especially when they see the hens wandering happily outside the studio. In fact, it's really quite simple, and there are some formula tricks that will help you liven up your landscapes with chickens, sheep, cattle and other animals.

I use my blob-shadow-highlight formula. It is a bit of fun but has instant results. It uses light, medium and dark tones to create a three-dimensional shape. The 'blob' refers to the initial shape of the animal, not a thick dollop of paint. I used pastels to create the sheep and cattle shown here, but oils or watercolours are just as successful. By changing the shape and colour of the blob, and adding shadows and highlights you can apply this formula to any animal.

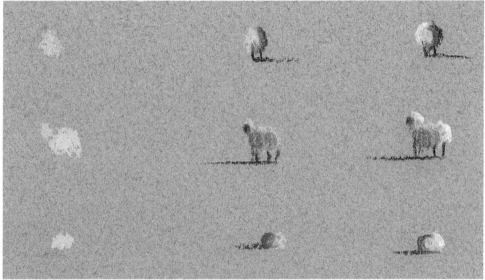

SHEEP
Begin by drawing a blob for the body with raw sienna pastel. Next add shadows on one side of the body, the legs, and on the ground. Highlight the opposite side of the body with white and you have a sheep. Try a different shape, perhaps with a head. Add shadows and highlight and a side view emerges. A round blob becomes a sheep lying on the ground.

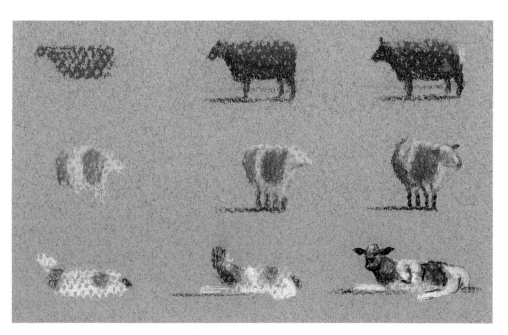

COWS
By changing the shape of the blob and the base colour to brown, tan, or black and white, you can add cattle to your landscapes instead.

Once you have practised the blob-shadow-highlight technique, try placing animals in a simple fieldscape. When using pastels, most work is executed in a loose, painterly fashion. In the sketches below I have quickly blocked in a background, then added a scattering of blobs. When one or two examples of these blob-shadow-highlight sheep are in the landscape, the rest of the flock can be mere dots and dashes in the distance.

A suggestion of field and sky with soft green and sky blue pastels on a mid-tone paper. Light-coloured blobs give the position of the sheep.

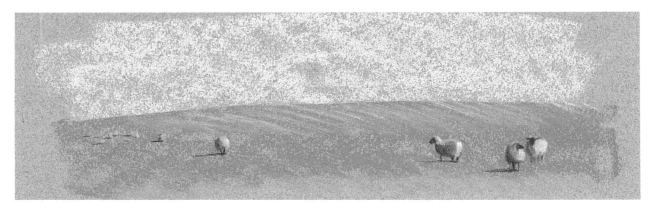

When you have decided on the direction of the light, the sheep in the foreground and middle distance will come to life with the addition of shadows and highlights. The distant animals are reduced to dots and dashes, but are still effective.

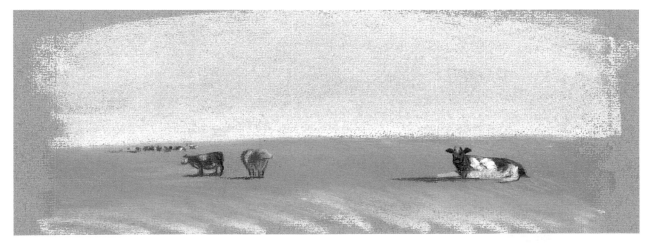

Keep animals to the middle and far distance: this way you can avoid detail and still add credible cattle to your landscapes. Anchor the animals to the ground with the all-important cast shadow.

DEMONSTRATION

ADDING SIMPLE DISTANT SHAPES TO SUGGEST LIFE: KINKELL

This simple landscape offers an opportunity to add suggestions of animal life in the distance. If the idea of adding livestock to a landscape terrifies you, the demonstration will help build your confidence as all the animals, both sheep and cattle, are kept well away from the foreground, so you can add them without fear of getting involved in too much detail.

Stage 1

Using white on a light blue, good quality pastel paper, I sketch in the general composition without detail, dividing the scene into its main sections. The sky is blocked in with white too, applying it thicker on the lower part of the sky where it will be lighter, then adding a light ultramarine tint on the top half, and light raw sienna tint on the lower half.

To strengthen the upper part of the sky, I add a deeper tint of ultramarine, which will be blended later to create a smooth, uncomplicated sky with recession. By blending in, I also cover the paper's colour and tone, which would be too dark otherwise. The field behind the bridge is catching sunlight so I block it in with a pale lemon yellow tint and add a mid green across the remainder of the fields. In the foreground I use permanent sap green tint 4, with tint 1, which is paler. All these colours remain unblended as the texture of the paper adds to the landscape, and the colour can show through in areas where the pastel remains thin. The bridge is blocked in with caput mortuum tint 1– a delicious colour range of pinky greys.

STAGE 1
Simple blocks of colour applied with no blending prevent the pastels from becoming muddy and lets us see the effect of the colour mixes where they are laid on top of one another.

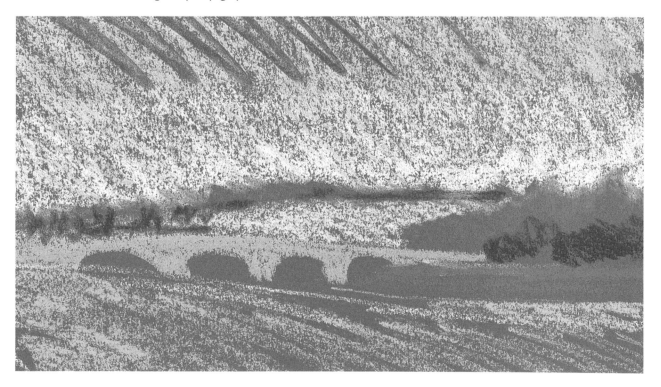

STAGE 2
The landscape is almost complete, but needs some animals to add life to the composition.

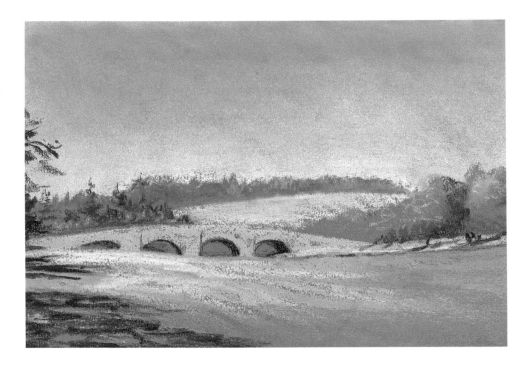

TIP

Keep your first attempts simple. Do not add too many animals to your landscapes and make sure that you place them in the middle and far distance.

Stage 2

I blend the colours in the sky area with my index finger to create smoothness and to block out the paper colour. This creates a soft, mellow effect because of the pale raw sienna. Then I use the same tint of ultramarine as in the top of the sky over the distant trees to push them further back. A very dark green – pthalo green – suggests trees behind the bridge.

I add some Winsor yellow to the front field to intensify the feeling of sunlight. To warm it further, I touch in some golden ochre. I add some highlights on the trees on the right, as well as a touch on the foreground trees to the left, with lemon yellow. The mid green for the fields is now applied thicker to block out the paper colour, while strong shadows are added in dark green with touches of indanthrene blue tint 5 on top to cool the area. The scene is now set, but what can we add to give it a bit of life?

Stage 3

Some blob-shadow-highlight cattle and sheep are the answer. But first, with dark green, I add an almost dotted line to divide the main field into two areas. The distant half will have a suggestion of cattle. Using burnt sienna tint 4, I dot several blobs of colour, grouping them informally, and add a few spots of white. I position the nearest sheep by adding blobs of pale cream. Where the field is at its lightest, I use a darker cream to help the shapes to stand out better. I continue the sheep further back with white, even tinier, randomly scattered blobs.

Stage 4

All that is needed now is to anchor the spots to the ground and we have livestock! Every shape needs a shadow to keep in mind where the light is coming from. Once the nearest sheep have a few white highlights too there is, quite suddenly, a suggestion of life.

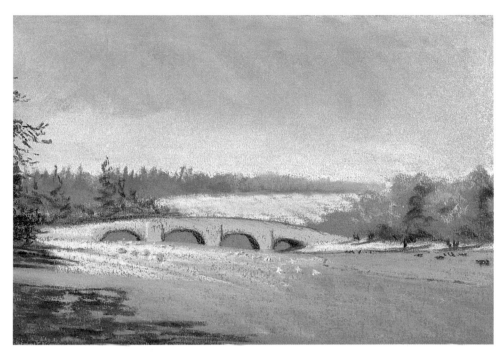

STAGE 3
*The beginnings of life
are added at Stage 3.
By Stage 4, Kinkell has
come to life with flocks
and herds of grazing
animals.*

STAGE 4

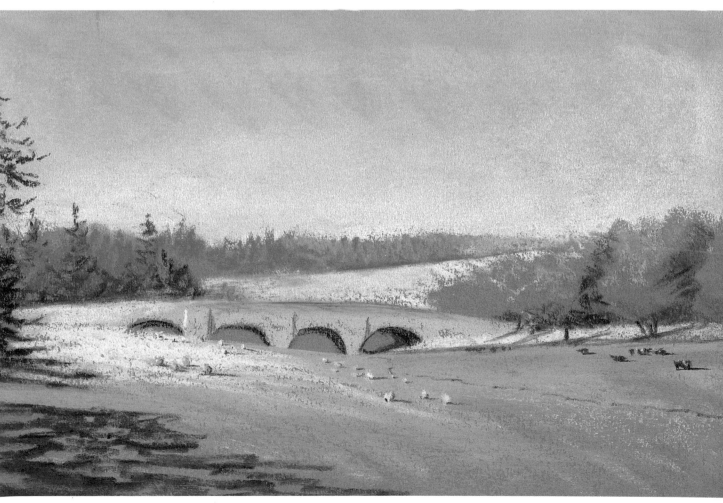

CHAPTER THREE
SCALE AND EMPHASIS

WHAT PART DO YOU WANT FIGURES AND ANIMALS TO PLAY IN YOUR
PICTURES? USUALLY, THEY CREATE A FOCAL POINT, BUT THEIR
IMPORTANCE TO THE COMPOSITION CAN VARY WIDELY: THEY MAY BE
INCIDENTAL OR EVEN THE DOMINANT ELEMENT.

Scale and emphasis are central points of composition when including figures or animals
in a painting. The scale of a figure or animal is its size in relation to the rest of the
picture. The emphasis, or importance, a figure or animal takes in a painting depends
on its size and its position in the composition. If the figure or animal is the most
important part of the painting, then it will stand out and the rest of the composition
may become incidental.

Getting the scale of figures and animals right in relation to the rest of the scene is

*This painting in pastel
pencils was based on
a 10-minute sketch I
made in the quiet
French village of Lille-
sur-Tarn. There was
almost no one about,
and it was the shafts
of sunlight that
caught my eye. Later,
when re-working the
composition I decided
to add a feeling of
village life by putting
in some distant figures,
using the 'stick'
technique (see page
16) and being careful
to keep the figures in
scale with the
buildings.*

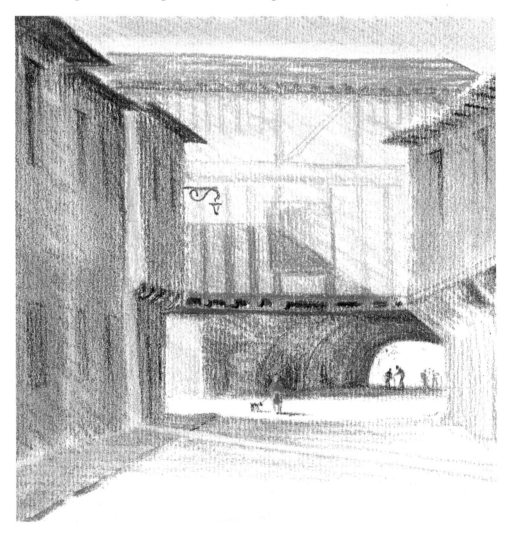

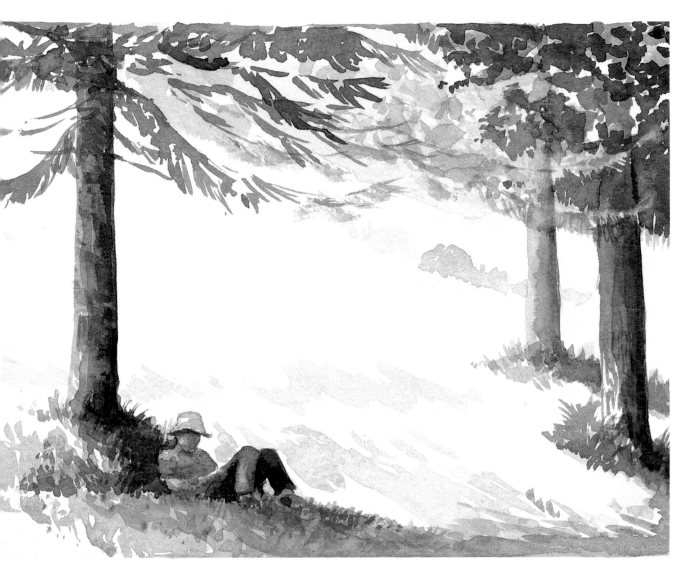

important. This is true whether they are an integral part of the painting right from the start, or added to a landscape or townscape as an afterthought to liven up the composition. For instance, will they fit through doorways; how high are they in relation to gates or trees; are animals and people in scale with one another?

If you wish to give figures and animals equal emphasis to their setting, all the elements of the scene must be considered in relation to one another right from the start. So you need to observe carefully and check the relative scale of buildings, trees, landscape features and the figures and animals in their setting as you work.

When you want to add a figure or animal to a picture as an afterthought there is also a practical consideration. How will you superimpose it on a landscape? With pastels or oils it is simply a case of placing your figure wherever you want it, as you can apply light on dark and dark on light. However, you may be governed by choosing the 'easiest' area in some cases. For example, if you are working in watercolour it is simpler to add a dark figure to a light area than to 'lift out' colour in a dark area in order to place a figure or animal in the composition as an afterthought.

In this watercolour sketch, the figure spotted resting under a tree is as important as the rest of the scene. I built him into the setting, painting around him first.

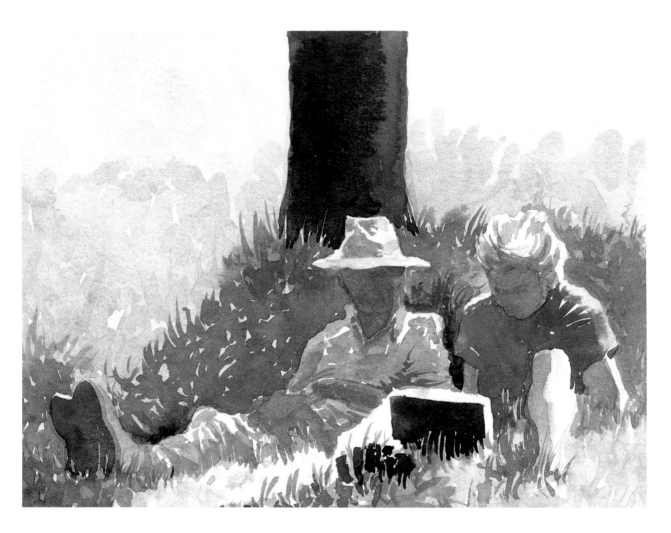

Here, the watercolour study is all about the two figures; they dominate the composition and their surroundings are less important.

Where the figure or animal is the dominant element of the composition, the scale of the subject is generally larger, and the background more incidental. Even when figures are seen close up (see above) it helps to keep facial features understated which keeps the painting impersonal and helps the viewer to concentrate on what the figures are doing, rather than who they are, or what they look like.

SELECTING THE SCALE AND EMPHASIS

How do you decide on the scale and emphasis in your paintings? Sometimes, the choice will be instinctive and you will have a picture in your mind of how you want the painting to be. However, you can try out your ideas in a sketch first (see opposite). As we have already seen, the size and position you decide to give the figures alters their impact. It can also alter the mood of the painting. If you want your painting to be intimate, then a painting where the figure is in the foreground or the middle distance will create greater intimacy with the figure than with the landscape. As with photography, zooming in on a figure in a painting concentrates attention on the figure and sets up the beginnings of a story: who are they? what are they doing there? what will they do next? Try the exercise with your own subject matter and see the results for yourself.

Figures or animals placed in the distance will help to give the surroundings a sense of scale that adds to the mood of the painting.

By moving in closer on the figure, the emphasis is altered and so is the mood.

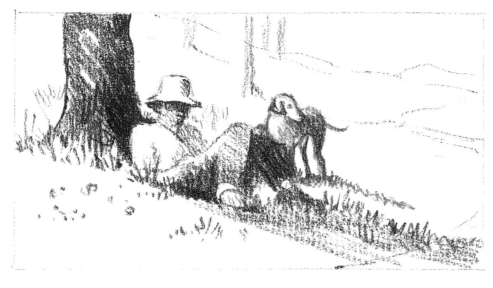

Zooming closer still gives even greater intimacy with the focal point of the painting.

HOW TO PLAN A COMPOSITION WITH FIGURES

THE GROUSE SHOOT

The prospect of creating a composition with figures can be daunting, especially if you try to capture figures and landscape together in one go. It's much better to tackle each component separately in sketches, and combine them into one composition later. Here, I show you how to set the scene first, in this case a Scottish grouse moor, with the intention of adding figures in the distance, the middle distance and the foreground, later. Sketching time is often limited. This project is based mainly on photographs, together with a few quick sketches (Figs 2–6) done on the spot.

FIG 1

Once the basic scene is set you can plan the position of the figures. Do not try to do everything at once. Before you begin, make many sketches of individual figures and animals, try a few settings for the scene, and take photographs. Later, you will be able to put these components into one composition.

The first step (Fig 1) is to compose a very simple scene without figures. I choose a blue-grey pastel paper and soft pastels. Starting with a pale ultramarine tint, I quickly sketch the general layout of the landscape: just large, simple areas of colour without many features to create distance, middle distance and foreground. I block the sky in next, using white on the lower area, and pale blue on the upper area. I add a pale raw sienna tint to warm the clouds slightly. To keep the sky soft, especially around the area on the right where I intend to put my foreground figure, I blend these colours to merge the cloud shapes. I then block in the distant hills with the same blues, adding soft green where the hills are closer. I use yellow ochre where the field colours are broken with golden tones, and suggest the distant heather with ultramarine violet warmed with touches of pink in the foreground.

From these quick pencil sketches done from life I need to select figures for the foreground, the middle distance and the distance.

FIGS 2 AND 3
These are figures for the foreground. As Fig 3 is looking in towards the scene, I opt for him as my main character.

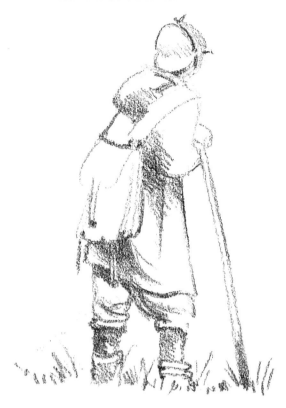

FIGS 4 AND 5
Two sketches that could be useful as middle distance figures. In the end I select Fig 4, who will lead the eye into the scene, by looking towards the distant figures.

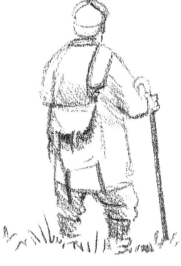

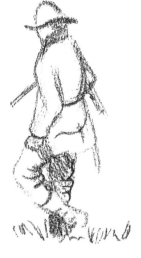

FIG 6
A selection of little men to use as distant, incidental figures. They were drawn at the shoot using the 'stick' method, and will be most effective in giving some idea of the vast scale of the moor, and the distances involved in the painting.

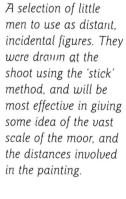

The final stage of the painting is to add the selection of figures to the landscape. The largest figure on the right is added first, using the dark green to block in his shape, regardless of colours in clothing, skin and so on, as he needs to be dark against the sky line to give him emphasis. Next, using pastel pencils, I highlight him from the back with a portrait pink, then I add shadows with dark grey. To help merge the figure with the surroundings I keep the colours as close to those of the background as possible. I resist the temptation to do the face in detail as the eye should be drawn towards the other figures in the painting. However, his dog is very important to the composition. He is close to his master, yet, because he is turning round to look into the scene, he leads our eye further into the landscape too. I block the dog in with dark brown, using the same pink highlights to catch the back of the head and neck.

The middle distance figure is next: another gamekeeper who is watching the action with dogs by his side. I place him towards the left. This time, the need for detail is minimal, and I block him in with a dark green that stays throughout the figure, and I use it for the dog and the walking stick – a compound dark silhouette against the light of the hills and fields beyond. I finish the group off with a few highlights on the side, and some dashes of white and orange to suggest another spaniel.

The art of suggestion continues further into the distance, as the tiny figures with guns are dotted around the field. To finish off, I add heather texture with dots of purple and pink, and dark green shadows on the ground. The lack of feet not only hints at thick growth underfoot, but anchors the figures and animals to the ground.

FIG 7

The final painting of the grouse shoot shows foreground, middle distance and distant figures. Each helps to give a sense of scale to the painting and highlights the majesty of the grouse moor. The composition is a dramatic balance between the figures and the landscape.

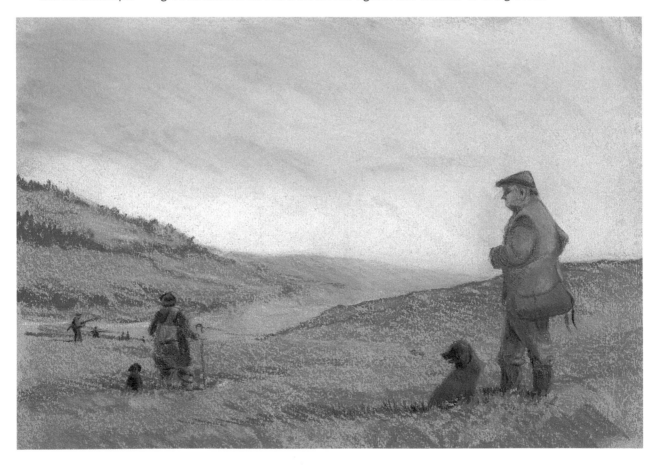

ARTISTS' AIDS

VIEWFINDERS

If you have painted landscapes before, you may be familiar with using a viewfinder to help you compose the scene. You can also use a viewfinder to help you plan the composition when you want to add figures and animals to your paintings. It is an especially useful device in close settings, where it will help you to see the proportion of the subject in relation to the entire picture area. Then you can decide whether it is too dominant or too insignificant. I prefer to use a viewfinder composed of two separate L-shaped pieces of board (picture mount samples are ideal), as I can overlap them to change the picture proportion for landscape, portrait, or panoramic formats. The static, one-piece viewfinder with a fixed aperture gives only one proportion and is much less flexible. However, it can be useful in planning full-length figures because you can use it to help divide the body into proportional sections.

USING A PENCIL AS A MEASURE

When you see artists squinting and holding a pencil or paintbrush out at arm's length they are not trying to draw attention to themselves, they are checking the proportion of a figure.

This is how it works: hold your pencil out at arm's length and place the top of the pencil in line with the top of the head. Run your finger down the pencil until it is level with the chin, then check how many times this proportion (the head) goes into the remainder of the figure's height. Remember the head is one eighth of the total height of a standing person.

THUMBNAIL SKETCHES

These are freehand doodles, which can be very rough and free. You can use them to catch a situation before it changes, as below, where the waiter is about to serve some customers. Scribbling down an idea like this in a notebook, on a scrap of paper, a napkin or even an old cigarette packet can give you an idea for a painting, even if it is not executed very accurately.

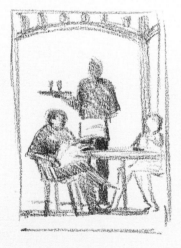

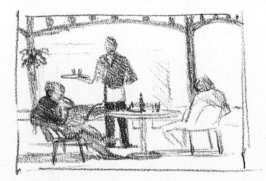

Thumbnail sketches are also useful for planning whether a composition is better on landscape or portrait format.

DEMONSTRATION

PLANNING A COMPOSITION WITH A FIGURE IN SCALE: FARM SCENE

In this landscape-with-figure demonstration I show how to plan a composition to include foreground figures and animals so that they are in proportion to their surroundings. As in the grouse shoot, I make the painting in several stages, creating it from a series of sketches and trying out different combinations until I am happy with the composition.

STAGE I

The first stage is to sketch in the setting. At this stage I do not work in detail, especially in the middle distance and the foreground, as I want to plan where to place figure and dogs.

Stage I

On a mid-grey pastel paper I sketch in the basic scene. I keep the sky very simple by blocking in with white, which I apply more thickly on the lower half. I add ultramarine on the top half and pale raw sienna on the lower half to give a soft, mellow atmosphere. I block the distant hills in with pale ultramarine, which blends in with the sky, and I add blue-greens and lilacs to create a sense of warmth, as well as distance. The cluster of distant farm buildings I block in with caput mortuum, which matches the pinky-grey of Perthshire stone, while the background trees, which help to project the shape of the buildings, are blocked in with dark pthalo green. I take a soft light green across the fields.

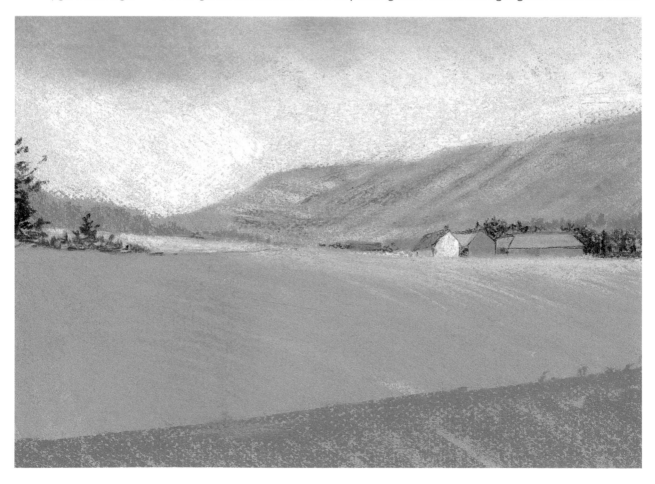

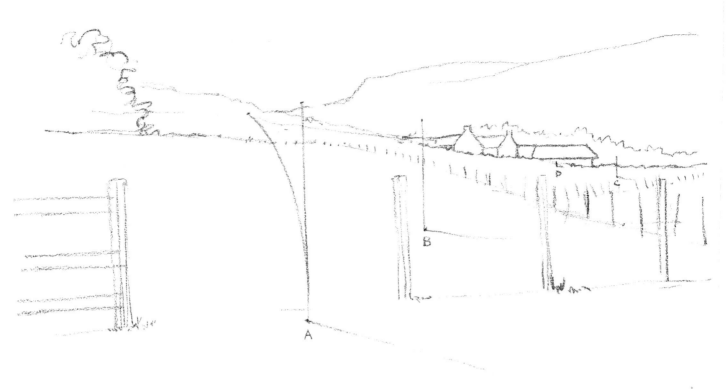

To indicate the direction of the sun I highlight the field on the far left behind the dark green foreground trees with lemon yellow.

I use directional strokes of the pastel to build up the main field; these help to give a sense of perspective and suggest slightly uneven ground. In the foreground I build on the existing green with a darker green pastel in order to separate the area from the field, which will be fenced off. The scene is now set, and I must make the extremely important consideration of the position of figures and animals before adding them.

Stage 2

The plan is to have one main figure, perhaps the farmer, standing by the fence with his dogs. There will be a few sheep in the field, mostly distant suggestions, with a few coming over towards the fence.

I prefer to try out a few alternative figures and dogs on a separate sheet of paper before making my final decisions and adding them to the scene. I roughly sketch a pencil plan of the scene and try out several places where the figure could stand. I place one (B) inside the fence perimeter and the other (A) in the foreground, outside the fence. The position in the foreground seems the most suitable of the two, as I want the farmer's dogs by his side where they won't be able to chase the sheep! I have indicated an upright position and also a slightly bent position, this is because I may want the farmer to be stroking his dog.

If I had wanted to place the figure further away I would have used positions C or D. Notice how they are in relevant proportion to the surroundings. It is amazing how a simple stick mark, with its relative shadow cast on the ground, helps you to visualise where to place both figures and animals in a composition.

STAGE 2
A pencil sketch of the composition gives you the opportunity to work out where you will place figures and animals. You can draw in a 'stick' in different positions, which will help you get the scale of the figures correct and ensure that they are in proportion to their surroundings.

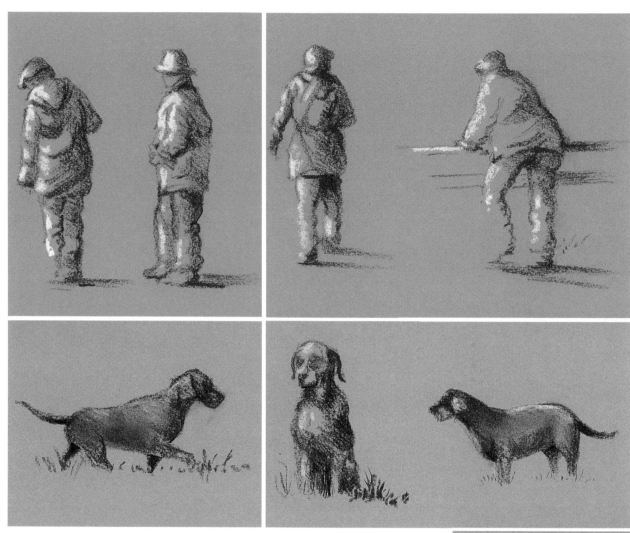

Because I have already included it in the painting, I use pthalo green for the figure and the dog sketches, knowing that it will be in harmony with the rest of the scene. It is important to match the tones of added figures to those of the surroundings if they are not to jar and spoil the painting.

Stage 3

Now for the figure and dogs. I want them with their backs to the viewer, looking into the landscape. This helps to lead the eye into the scene, especially when the figure is a prominent size. If it were to face the viewer it would impose on the scene and I might be tempted to give the face features. Keeping the character anonymous concentrates attention on the entire scene and not just on the figure.

Before making my final decision, I sketch a few practice figures in different poses so that I can see which pose best suits the composition. I also make several dog studies. All the sketches are done in pastel on a mid-tone paper, similar in tone to the area where they will be positioned on the painting. I sketch them in with a dark pastel, in this case pthalo green as it is dark enough to make the figures stand out against the background.

Stage 4

I am now ready to add the final choice of figure and dogs, so I sketch in the farmer I have chosen from my sketches with pthalo green. I keep the colour light where highlights will be added later, and heavier on the shadow side, continuing onto the ground where the cast shadows will go.

The relationship between man and dog is important so I position the left-hand dog first, to check out the scale. Once I am satisfied with the two characters I add the second dog. I use pthalo green for both dogs and their cast shadows.

Now that I have a tonal outline of the characters, I can start to add colours. I begin with indanthrene blue for the man's jacket. I also use it for the general colour of the labradors. Note that I do not use black as it would be too stark, and a very dead tone. I add touches of raw sienna on the trousers, cap and face. I use pale ultramarine to highlight the jacket and the dogs.

The fence posts are added next, positioned carefully to leave sufficient space for the foreground sheep. After that, I add the crossbars with a dark brown and over-paint them with the dark greens and dark blues to integrate the colours with the scene. I use the brown on the farmer's cap and trousers to tie it into the scene. A few close-up sheep are added with pale raw sienna. Then I add highlights with white, and shadows with the dark brown to create depth.

STAGE 4
The nearer sheep are positioned to lead the eye through the foreground to the flock, then across the background, through the farm buildings and back again.

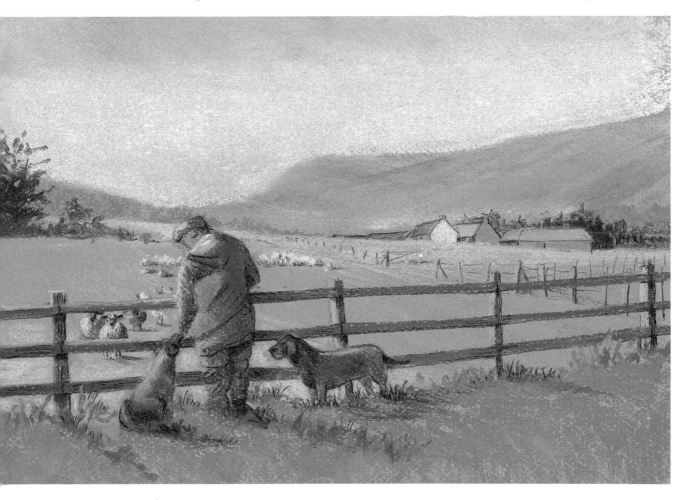

47

TONE

Tone is important to the success of a painting. It adds depth and helps to create an illusion of distance. Tone can lend drama, particularly through counterchange, when dark is seen against light, and light against dark.

TONAL SKETCHES WITH PENS

Tone refers to the lightness or darkness of a subject regardless of its colour, so the pen is an ideal medium with which to explore tone. Tonal sketches record the subject in terms of light, mid-toned and dark areas; they do not use colour. An area of shadow in a tonal sketch can be rapidly blocked in with angled hatching, or cross-hatching, as you prefer. The tone can be deepened by building up layers of hatching. When you work with a pen, you can vary the angle of the hatched marks to follow the direction of the object, which helps to show form.

Beginners often shy away from pens because they think they make indelible marks. However, if you use a pen with water-soluble ink, you can soften the line with a brushful of water, which can disguise, or even eliminate mistakes. Water-soluble ink pens also give a free and spontaneous line, which is particularly good for capturing movement.

I like to experiment with different brands of pens and different types of paper. I find that watercolour paper gives the best results, as it is designed for washes. However, a free, quick, sketchy effect can also be achieved on cartridge papers too. Some are heavier in weight to take light washes, although some can be too absorbent.

The pen sketches here show the different tonal effects that can be achieved with the same pen. The figure on the right shows another technique to create tonal value: negative painting. The outline of the subject is created by shading around it, leaving a light shape against the dark background.

These quick sketches show the different effects you can create with the same pen. On the left, the pen was used with water to create soft washes of tone. On the right, shading was created with directional strokes of the pen alone.

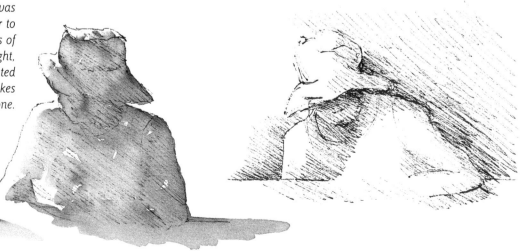

USING COUNTERCHANGE

The use of tonal contrast and counterchange to achieve impact is one of the most important aids an artist has. Counterchange refers to the technique of alternating between dark and light, depicting an area of the subject as dark against light and another area as light against dark. This effect can be exaggerated in your work to make a subject more prominent.

Artists frequently use counterchange to help project an image. By exaggerating the tonal contrast between figures or animals and the background, you can give a greater impression of depth and at the same time add drama to a painting. It is possible to create a focal point or lead the eye through a painting by doing this, as the strong contrast will draw the viewer's eye, either to merge into a background, or to stand out and make an impact. Subjects can be lit up against a dark background, or, like a silhouette, stand out against a light background to dramatic effect. Before you begin to paint or draw it is important to walk around a subject so that you can decide from which angle the counterchange is most effective.

If you have already created a scene and later decide to add figures or animals it is not enough to be aware of the direction of the light source and the appropriate shadows. You need also to be able to position the subjects so that they catch the eye and become the focal point of the picture.

TWO DIFFERENT FORMS OF COUNTERCHANGE.

Below left: the figure is seen as a dark silhouette against a doorway flooded with sunlight. The colours of clothing, skin and hair would be virtually blocked out by the depth of tone, leaving only an edge of highlight and a deep cast shadow.

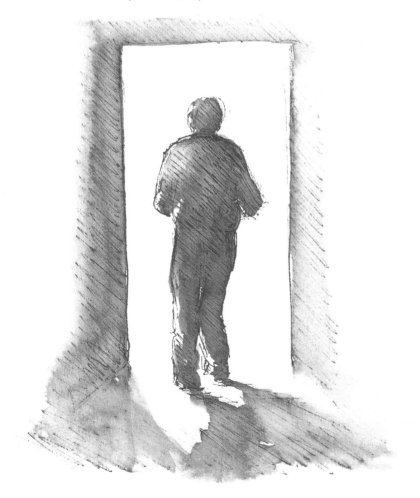

Above: the dark doorway projects the light figure, creating a light against dark scheme. I used a pen with water-soluble ink, which dilutes when water is added to the line, giving fluidity to the lovely bold shadows.

GETTING CLOSER

When sketching closer subjects, especially if they are aware that you are sketching them, you have to become a little braver. It is time to try sketching members of the family as they read the newspaper, or watch television. This is almost like tackling portraits, but there is no need to worry about likenesses yet as the drawing should remain sketchy and without detail.

In Fig 1 anonymity is preserved by concentrating on the negative image of the head, which is almost completely light against a dark background. However, in Fig 2 I have begun to use the slightly more complex technique of alternating between dark and light across the subject: dark background against the light side of the head, and dark side of the head against the light background. The technique helps to create space around the head and is a traditional method used by portrait painters (see Chapter Seven).

Finally, the setting of the full portrait sketch in Fig 3, demonstrates the use of this successful technique to achieve side-lighting with a touch of drama.

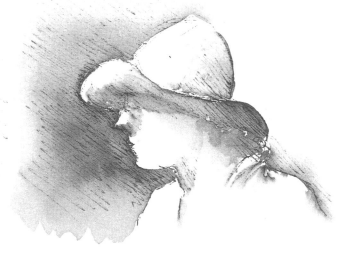

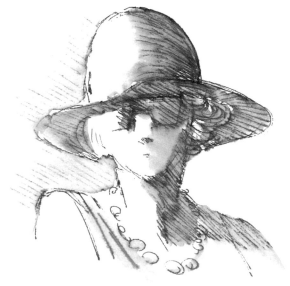

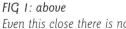

FIG 1: above
Even this close there is no need to worry about detail.
The pale head stands out against the dark background
– a strong example of negative painting.

FIG 2: above right
The front of the head is strongly lit in the sunshine
against a dark background, but the back of the head is
in deep shadow against light.

FIG 3: right
This quick sketch, done with a pen and sepia water-
soluble ink, shows the light coming in from the side,
while subtle shadows provide the composition with a
rounded, three-dimensional effect.

USING NEGATIVE PAINTING TO ACHIEVE COUNTERCHANGE

Instead of painting the actual subject, you can paint the background around the subject, using the background to create the shape of the subject. This works particularly well in situations where a subject is much lighter than the background. And where detail is not required – distant sheep or cattle in a field – the pale shape against a darker tone may be enough on its own.

Negative painting is most frequently used in watercolour techniques when paper needs to be left white to create highlights. If a subject needs detail then you can return to work on it once the shape is in position against the background.

In the simple watercolour sketch of sheep in a field (below) the animals were quickly positioned by painting around their bodies with a pale green. Even a flock can be suggested by the same negative painting technique, with pale green above, but this time with a blue grey below to suggest the road.

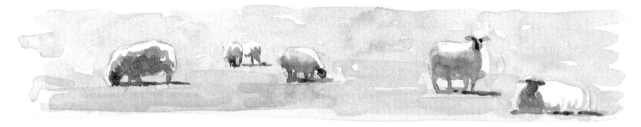

The sheep were positioned by painting the background around the animal shapes first. Sunlight hits the tops of the animals so their backs are light against dark, but the lower bodies are in shadow, dark against light.

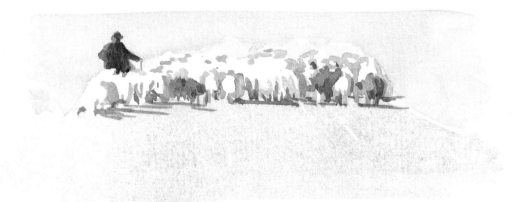

When this shepherd and his flock blocked a country road I quickly sketched them. The strong impact of the shepherd's dark silhouette and the sheep's shadows on the sunlit road provide a perfect counterchange situation.

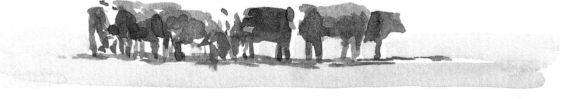

Without being much of a dairy farm expert, you can suggest a herd of cows with negative painting.

COUNTERCHANGE IN WATERCOLOUR SKETCHES

Counterchange is a little similar to the question of the chicken and egg – which comes first, the subject or the background? The following exercise shows how vital it is to create a contrast between subject and background if you want to show the subject of a painting to best advantage.

Look carefully at the hen studies on white paper on this page. They are definitely in colour, but there is no indication of surroundings, so the 'white' hens do not show up well. They cannot because there is not enough tonal contrast between them and the white paper on which they were painted. Try painting some 'white' hens on white paper yourself and you will see that what they need is a contrasting surround.

Without the contrasting tones of a background, these hens are indistinct. They have tonal variation within their own shape, but they still need a surround of a different tonal value.

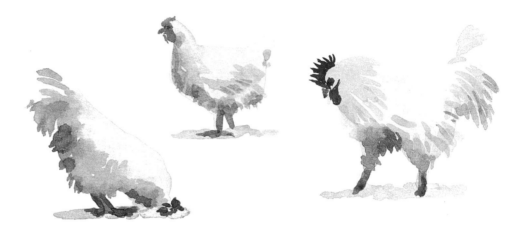

The hen and cockerels below have some background colour around them and you can see how the background helps to project each bird. Practise some hens and cockerels yourself (you could try some 'white' hens again later) but this time add some background colour. But which should you paint first, the chickens or the background?

Start by sketching the birds with a very pale raw sienna. Next, add a pale green background wash around the body. This leaves the subject framed in green. Then build up the colours on the birds. As the colours are added, darken the background colour where it is against the lightest part of the bird. This will help to project it.

How much better the cockerel and the hen stand out against their backgrounds. Notice where the counterchange alters around each body: the green background is darkest where the bird's body is lightest, and against the dark tail feathers and legs the green background is very pale.

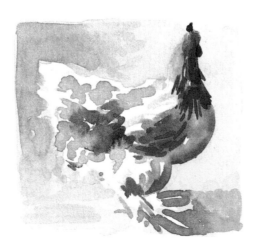

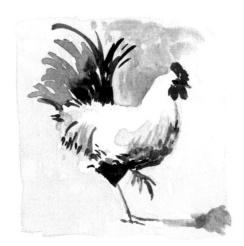

COUNTERCHANGE IN A WOODLAND SETTING

Once you feel confident with using colour for counterchange around your figures and animals, the next step is to use counterchange to project them in a setting. Before I begin on a painting I always find it useful to make a few quick pencil or pen sketches. These help me not only to plan the composition, but also to see how best to set off figures and animals against their surroundings. In such sketches I can consider the tonal differences of figures and settings, and experiment with alternatives.

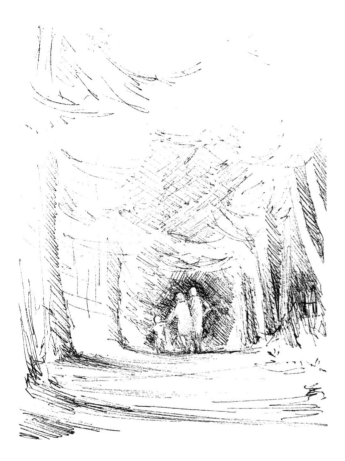

These two pen sketch plans show clearly two different ways of using tone to project figures in a woodland setting.

LEFT
The figures are light against a dark background.

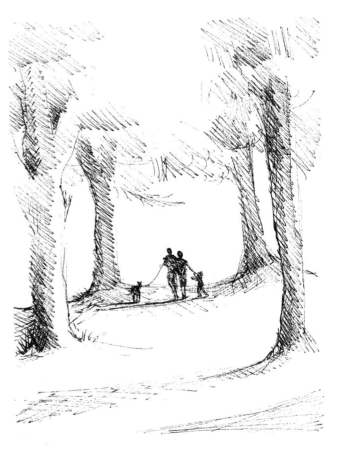

RIGHT
The figures are dark in tone to silhouette them against a light background.

COLOURED PASTEL PAPERS

Before you begin a pastel painting, think carefully about which colour paper will give the best effect. In other mediums the most commonly used paper or canvas is white, but pastel papers are available in such a wide range of colours and textures it is more usual to work on colours, rather than starting with white. The next two paintings (on this page and overleaf) are both pastels of figures in a woodland setting, but one is done on white paper and the other on grey. The idea is to allow the paper colour to show through in some places and, depending on the colour used, the effects achieved will be different.

WOODLAND ON WHITE PASTEL PAPER

White paper is useful if you want some very light areas in your painting. The plan is to have some figures walking into the light. When this is worked up into a painting, the background will remain very light in tone, allowing white paper to show through. So, although I am planning a pastel painting, it will build up from light to dark, as in a watercolour.

To begin the painting I sketched in the basic plan of the composition, such as pathway and trees, with a pale cream. Then, with the same colour, I blocked in the area where the sunlight shone through. To this I applied bright yellows and greens to add to the brightness.

To build up the great depth of the woodland I blocked in with deeper shades of green: cool for the more distant trees, then adding warmer greens towards the front. The brightest colours are concentrated between the two central trees to lead the eye through to the point where the distant figures will be placed. Next, I scattered a mid-tone green among the foliage.

I applied this build-up of foliage colour with the side of the pastel sticks, leaving a broad, broken effect to keep the foliage open. It is important to keep blending to a minimum because it may spoil the effect. Use it only in areas where you want the white paper to be completely blocked out.

I blocked in the tree trunks with dark brown and purplish-grey. After adding the pinks and pale oranges on the pathway, I used the same purplish-grey for shadows. I left white paper showing through in the foreground where the foliage is catching sunlight, and I added dark greens around it to give maximum contrast. Once the scene was set, I added the two figures in the distance, using the stick method.

WOODLAND WALK

White paper requires a quite different approach from working on coloured paper, as brilliant white can dominate the scene in the first stages if sufficient blocks of colour are not applied very liberally.

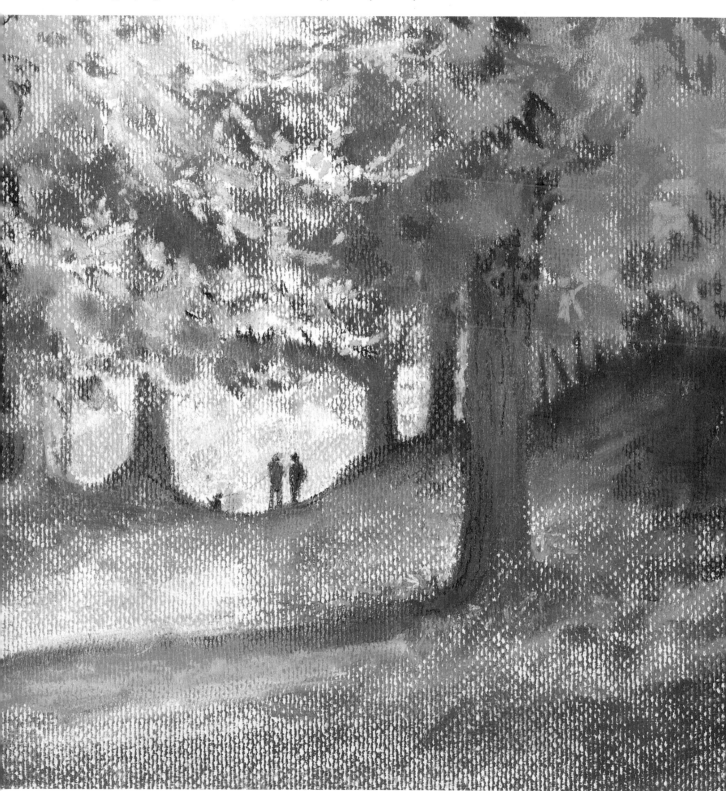

WOODLAND SETTING ON GREY PAPER

In this pastel sketch the paper colour is a mid-tone value, which makes it easy to add lighter or darker colours. In this instance, I started with a pale sky blue in the background, and added strong highlights of white, cream and pale yellow where the brightest points were.

From this, I developed the foliage in the same way as before, with cool colours gradually becoming warmer and stronger as they move towards the foreground. The distant figures are still dark against light, and a few strokes could indicate a dog or two – or is it a rabbit?

The point, however, is that the grey paper is still very dominant throughout the scene, and plays a large part in the colour plan of the sketch. Using the same colour pastels, you could try the same composition on different coloured papers to see how the effect changes. A very strong blue paper will give you a predominantly cool effect, whereas a deep orange or red paper could suggest a more autumnal feeling.

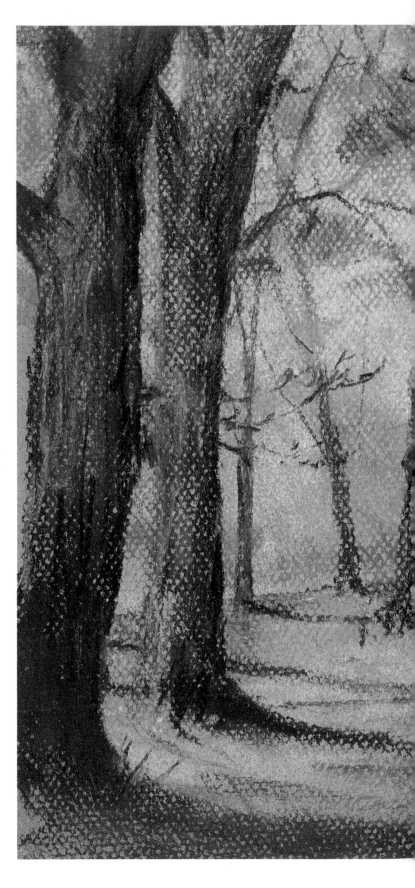

This pastel sketch sets dark figures against a light background. The grey pastel paper gives an overall tone that is easy to work with.

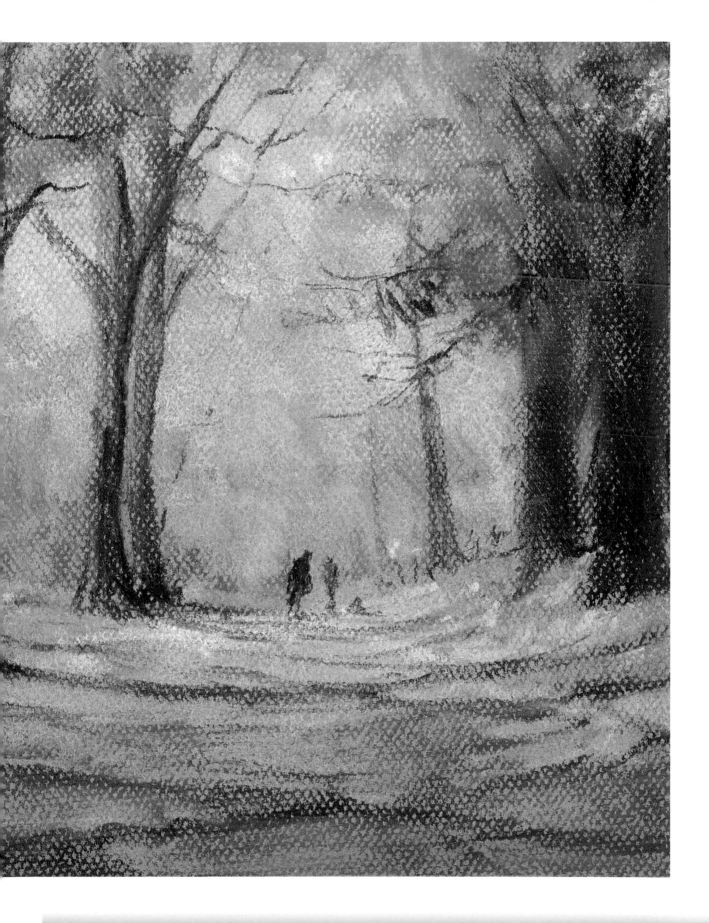

DEMONSTRATION

USING TONE TO SHOW FIGURES IN A SETTING: A WOOD

This version of a woodland walk is in oils on canvas. It was planned to show figures with a light edge against a dark background. Sunlight floods in from the side to create a shimmering pink glow against the greens. I used water-mixable oil paints (see page 127), in my restricted palette of seven colours, plus cadmium red and white.

Stage 1

To establish the main areas of the composition I block in the darkest area at the back using burnt umber and alizarin crimson. This is to create the feeling of walking into dense woodland. The warm browns and pinks are further away than the cool overhead greens that frame the scene, proof that for every rule an art teacher makes, someone is breaking it very successfully! I leave a few patches of white on the path to add sparkles of strong sunlight.

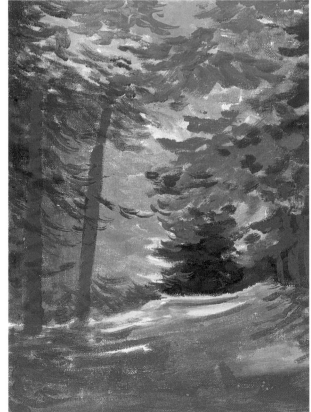

Stage 2

The main tree trunks are positioned using burnt umber and raw sienna. I add greens mixed from ultramarine and lemon yellow, making the mixture cooler in places with more blue, and adding raw sienna for warmer tints. I mix dark forest green and add it to the dark area, allowing some of the original dark red to show through. When I strengthen the ground colour with mixes of alizarin crimson and ultramarine, the overall tone pattern starts to appear.

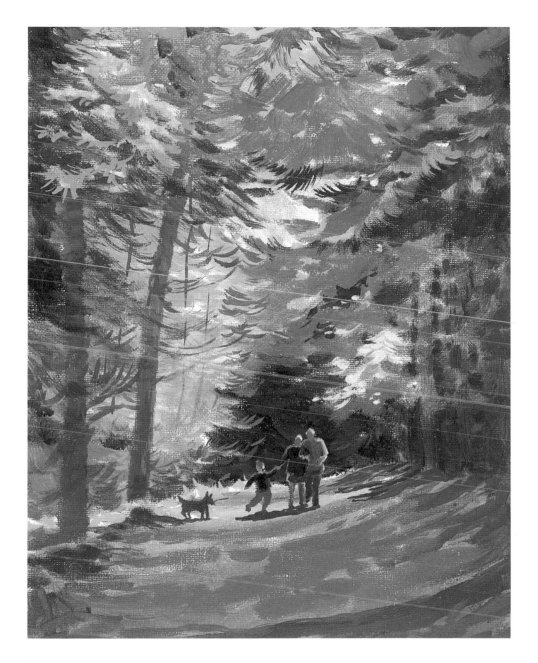

TIP

Remember that when you are painting foliage in oils you can paint light on dark as well as dark on light. Therefore, start from the background and work towards the front when painting foliage.

Stage 3

Now that all the main colour and tonal areas are in place, I shape the overhead foliage with delicate fringes. I place them light against dark and dark against light. To show foliage shapes against the sky, I mix a dark green from burnt umber, ultramarine and yellow and add it with a fine rigger brush. A bright yellow green with white and lemon yellow is sprinkled through the dark greens to hint at sunlight, and I add pale orange lights mixed from white, raw sienna and cadmium red. The white spaces on the ground are lightly covered with a pale pink.

The scene is now ready for the figures. I position them against the darkest area, with a bright light catching the shoulders, while the legs show up dark against the pale pink pathway.

MOVEMENT & GESTURES

OBSERVATION IS THE KEY TO CAPTURING MOVEMENT IN FIGURES
AND ANIMALS. MOVEMENT IS ESSENTIAL TO BRING LIFE TO PAINTINGS,
BUT YOU DO NOT HAVE TO BEGIN WITH OLYMPIC ATHLETES OR
GALLOPING HORSES: EVEN SEATED FIGURES MOVE.

UNDERSTANDING MOVEMENT

Painting movement in figures and animals can be daunting to beginners, but understanding how they move will help overcome any initial doubts you may have. I encourage my students to observe movement very closely and to keep drawings and paintings simple.

Sketching is a great way to capture movement because the swiftness with which you commit the figure or animal to paper helps to convey movement. Overworking drawings and paintings kills spontaneity and deadens the very movement you are trying to capture.

Try to spend as much time as possible observing figures as they move. You can do this on a bus or train, sitting in a park, or standing at the supermarket checkout. Notice the relative positions of different parts of the body as someone moves – hands and arms to shoulders, chest and head. You can try out some sketches later on. Some artists like to observe intensely for quite long periods (up to an hour) before they begin to put marks on paper.

When practising how to capture movement in figures, I often find it helpful to simplify the figure into ovals and circles. To draw the head, chest, legs, arms and feet I

FIG 1

A simple standing figure, but slight movement is captured in its raised arm, bent elbow and a leg that is just beginning to bend.

FIG 2

A jogging figure: note how the head is tilted back slightly and how the angle of the bent arms gives a sense of movement.

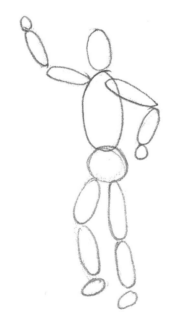

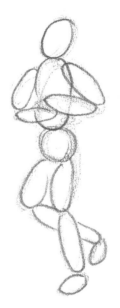

use oval shapes: the hips and hands are circles. The geometric shapes help me to see the joints of the body clearly, and since the joints are the place where movement begins this approach makes it easier to position arms, legs, feet, hands and the body and head correctly. If you do not have a model to sketch from you can position the body in movement, just as some artists use a wooden jointed mannikin. These geometric figures should be drawn in proportion – remember that in an adult the head is one eighth of the height of the figure (see Chapter Two). You can fill pages of your sketchbook with these little figures as you practise capturing movement in the body.

FIG 3
Not all the figures in your compositions will be standing. This figure could be bending to pick flowers. Note the relative positions of the arms and legs.

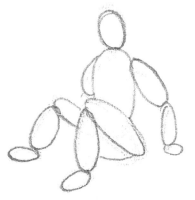

FIG 4
Another useful position for a composition. When placed with standing figures, the seated figure adds an overall sense of movement to a group.

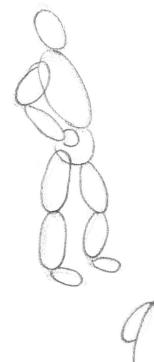

FIGS 5, 6 AND 7
More standing figures (see page 25). Notice that although the movement is very slight it still conveys what the figure is doing: Fig 5 is standing back and admiring the scene, or reacting to a conversation; Fig 6 is walking down the street; Fig 7 is elderly and needs to lean on a stick to walk, the shoulders hunched behind the head.

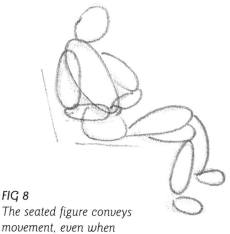

FIG 8
The seated figure conveys movement, even when relaxed (see page 25).

SIMPLE MOVEMENT

The movement you capture in your figures and animals need not be dramatic. What you need is an awareness of the different shapes the body makes when moving. There are some general rules to help you achieve this, such as the relative position of head and shoulders (see Fig 1).

Even in a relatively static pose, such as a seated figure, the posture is not always upright, and adjustments have to be made to account for natural movements, such as relaxing, slouching, or just leaning casually on a table.

The pencil sketches of head and shoulder below show how a simple movement, such as leaning forward, can be captured on paper quite easily. The movement is small, but it conveys something of the character and begins the process of telling a story: why is the figure leaning forward, what is he looking at or listening to so intently?

You can also use quick watercolour sketches to great effect when you wish to capture simple movement in animals or in humans.

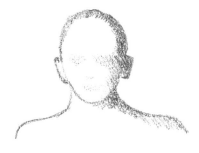

FIG 1
When the figure sits upright, the length of the neck separates the head from the shoulder line.

As the figure relaxes the neck relaxes too, and appears shorter. The head appears to sink into the chest.

When the pose is exaggerated by raising the shoulder level even higher, as much as halfway up the head, it will give the effect that the figure is leaning forward.

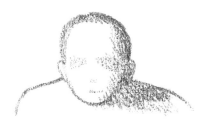

FIG 2
The same sequence of movements captured in watercolour, and taken one step further by seating the figure at a table and introducing the arms and upper body.

The watercolour sketches of these standing figures are rapidly done, but show how well a quick sketch can convey a movement if you are aware of the different shapes a body makes as it moves. I did these sketches straight onto paper with no preliminary drawing. Even the slight tonal variations where one leg overlaps another help to convey the movement too.

In Fig 3 we see how, with a few changes, a standing figure moves from a static pose to a run. Each figure is slightly different from the one before, but each conveys both a new movement and a sense of the movement about to be made.

By sketching the side view (Fig 4) of the same sequence we can further understand the general shape of a figure breaking into a run.

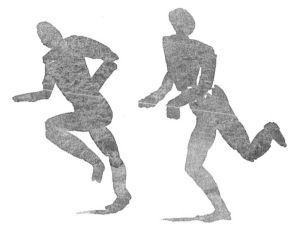

FIG 3
The front view shows a standing figure with both feet on the ground and arms by the side.

By raising one leg – seen in a foreshortened view – and bending the arms slightly to suggest a swing the figure begins to move.

More movement is created by leaning on one leg and slightly raising the other.

By continuing these movements the figure gathers power and speed and finally breaks into a run.

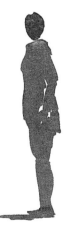
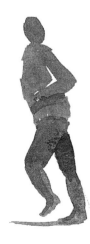
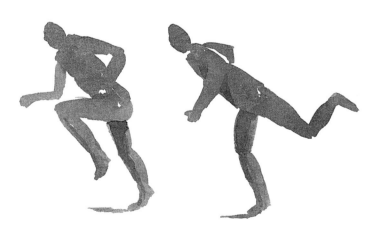

FIG 4
From the side view the figure stands upright.

Starts to move forward...

...and again leaps into action.

GENTLE MOVEMENT FROM LIFE

Once you have worked up some confidence by tackling sketches of moving figures you can move on to sketching from life. The subjects need not be extremely active – just moving about as they pursue everyday activities or hobbies, such as playing boules or golf. The rapid pen sketches of boules players are almost cartoon-like in style, but they capture the movement and character of the players. The understatement of the movement is strengthened by adding a subtle tonal wash (see Chapter Four) but it was about as much movement as some of the players could cope with.

Even sitting for as little as half an hour, studying these men, one learns that each has his own inimitable style or technique of throwing the boule. When combined with their individual shapes, this created a very diverse range of figures in action.

Once you feel more confident you could sketch a small group of figures with watercolour. The first stage is to capture the heads and arms, and to leave the clothing until you are happy with the understated movement of the turn of a head or hands clasped behind a back. Once the flesh tones are dry you can add the clothing, capturing not so much the detail as the mannerisms or gestures that each character makes.

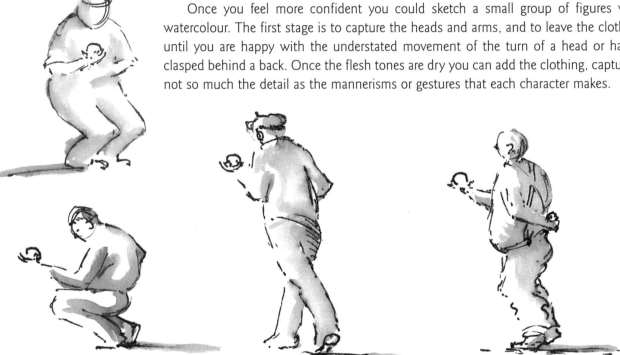

BOULES PLAYERS
These observations of townsmen in Cahors, France, playing boules were made from life. I used a black pen with water-soluble ink and diluted the ink line with a water-filled size 10 round brush, to give a lovely tonal wash.

The first stage in capturing the movement of these watercolour boules players is to mix a skin tone of raw sienna and light red, and plan the heads and arms in various positions.

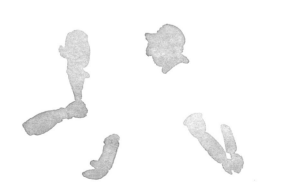

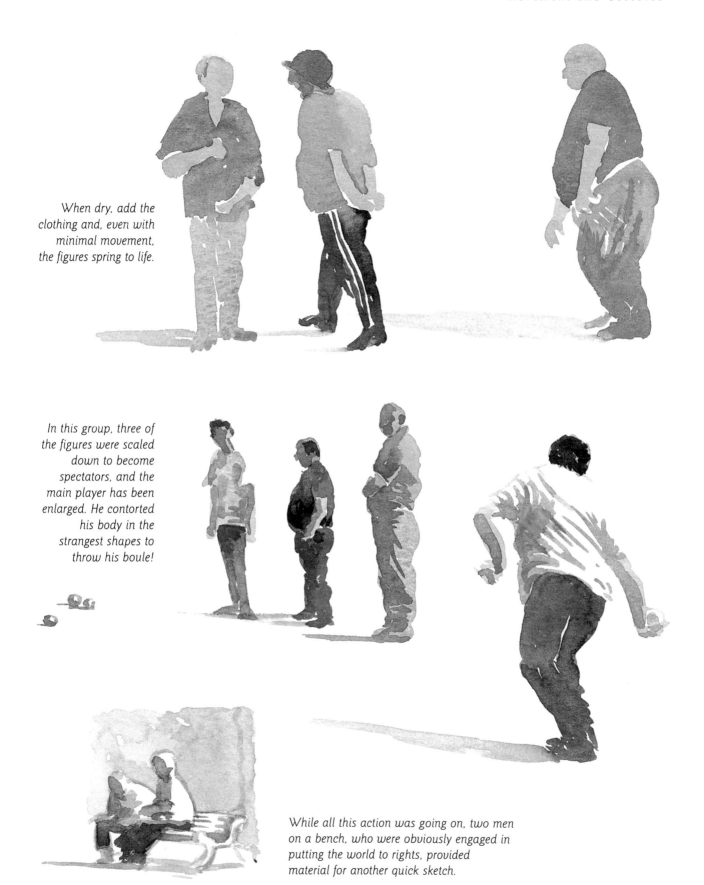

When dry, add the clothing and, even with minimal movement, the figures spring to life.

In this group, three of the figures were scaled down to become spectators, and the main player has been enlarged. He contorted his body in the strangest shapes to throw his boule!

While all this action was going on, two men on a bench, who were obviously engaged in putting the world to rights, provided material for another quick sketch.

MOVEMENT IN WATERCOLOUR

For some, capturing movement in watercolour is a daunting task. The myth is that, like pen, once the marks are made there is no room for error or change. My students are often shocked when I confiscate pencils for a day and insist that they go straight in with watercolour.

But it is easier than you think, and in situations when you are sketching in busy places, such as markets, or streets, or a beach where there is plenty of life and movement, it is better to go straight into colour, and not waste time with drawing, especially when time is of the essence.

As the array of figures from Viareggio beach will show you, whether they are leaping around with a beach ball, or quietly paddling in the sea, a few strokes of colour are all that's necessary to suggest the storyline. A range of characters soon emerges and you can develop one while you wait for others to dry, or work up several at a time if you see a selection of likely candidates come into view.

Don't worry if they are not all successful – some work and some don't – but the ratio of successes to failure quickly increases if you practise frequently in this situation.

When you are trying to work fast and sketch a moving target, it is easier to catch more detail if you cut down the choice of tools you work with. A fast-moving subject is not going to wait for you to sharpen your pencil, draw an outline, erase a few times, make alterations and launch into colour. Drastic tasks need drastic measures, so take a deep breath, reach for your brush, and go for it!

VIAREGGIO BEACH
A beach is an ideal place to try some movement sketches in watercolour. People are always busy doing nothing or being very energetic. Start with a pale mix of light red and raw sienna for skin colour and block in the bodies on watercolour paper.

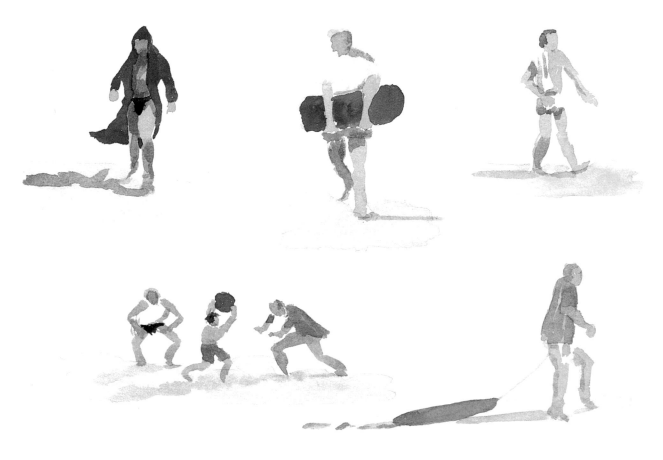

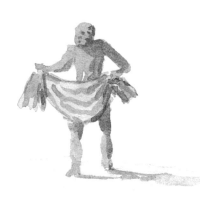
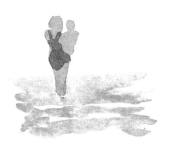
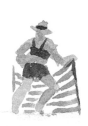

CAPTURING ACTION

Sometimes, in your pursuit of unsuspecting subjects to paint or sketch, you may strike it lucky when the figure settles and hardly moves for half an hour. While painting figures in the park with my students in Montecatini, Italy (the theme of the lesson was 'capturing action'), we were blessed with visits from two young ladies suffering from exhaustion on a very hot day. They went straight into my sketchbook.

The first collapsed onto the green bench, with her bicycle propped against her legs. As she was not likely to stay in that position for long, we had to work fast. After the cyclist revived and disappeared our luck continued as another hot lady in red dungarees arrived and promptly collapsed on the same bench!

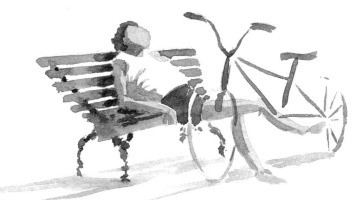

I captured the shape of the pose first, then the bicycle, then added the bench, which was an important support. These props are often very necessary to complete the pose and tell the story.

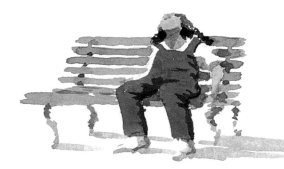
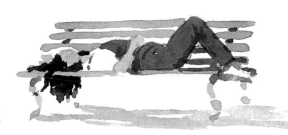

In both cases, the head was tossed back to rest against the bench. The initial wash of skin tone was repeated to create shadow under the chin. The final pose was too good to miss as she stretched out along the bench and her hair fell through the bars.

THE GOLFERS

Similar watercolour sketches, this time of golfers, also need little detail to look convincing. Small distant figures (Fig 1), such as those walking along the fairway, give a sense of scale to a golf course, and even the quickest doodle can indicate a duff shot in the bunker.

The movements of the two golfers teeing off also vary – probably according to their handicap stance! In Fig 2 the golfer's style was slightly ungainly, and the finishing position of his feet looked quite odd, but the hen-toed effect went into my sketchbook regardless. The shot was definitely heading for a birdie! The second golfer was more assured in his movement and a fairly professional golfing stance emerged.

FIG 1
If they are well observed, figures can always show strong movement, however small and lacking in detail they happen to be.

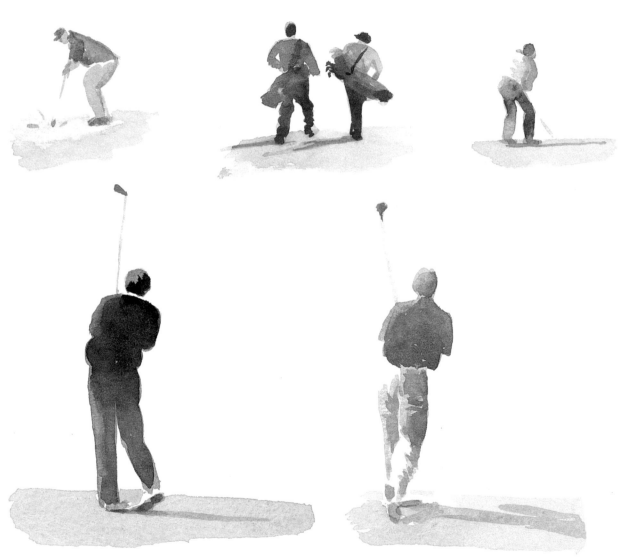

FIG 2
First I blocked in the head with skin colour, and then put in the body with a dark wash of ultramarine and burnt umber to create a neutral grey. I left a gap at the neck for his white collar, but the jumper was repainted to make it darker. Although his swing was ungainly, there is plenty of character in the movement of this figure.

FIG 3
I painted the head first, then put in the shirt with a pale ultramarine wash. The trousers caught strong sunlight so I left the paper unpainted to give a white highlight. I added blue down the side of the legs to indicate shadows. Notice the controlled lean of his stance, as if he is watching the flight of the ball.

CAPTURING MOVEMENT IN PASTEL

The boldness of pastel marks and the chunky sticks may put you off trying this lovely tactile medium. Yet what other medium allows you to capture in one stroke a subject's colour, tone and movement? Persevere with pastels and you will be well rewarded.

Most pastel sticks are fairly thick, which can make it difficult to draw precise lines with them. This can be to your advantage however, as a thick stroke keeps the drawing minimal, and the painting impressionistic – two qualities that help to convey movement. Different types of pastel give different types of line.

The strokes on this page are made by three different types of pastel. When you begin to plan a pastel painting that has moving animals or figures in it, you will need to consider which type of pastel to use. Thick sticks of soft pastels make it difficult to draw detail, but they make marks with one stroke, unlike the harder and thinner sticks, which are better for drawing with. Pastel pencils finish the trio. They are a neat, tidy way of dealing with pastel, and although they are harder than the others they are excellent to sketch with.

In this pastel sketch of a golfer, the bold medium with its broad line adds to the feeling of movement as the golfer completes his swing and watches the ball into the distance.

SOFT PASTEL

HARD PASTEL

PASTEL PENCIL

Different types of pastel make different marks. In each sequence shown above the first mark is made with the side of the pastel – ideal for blocking in; the second is repeated hatched strokes with the end of the pastel – a different method of filling in; and the third shows a single line.

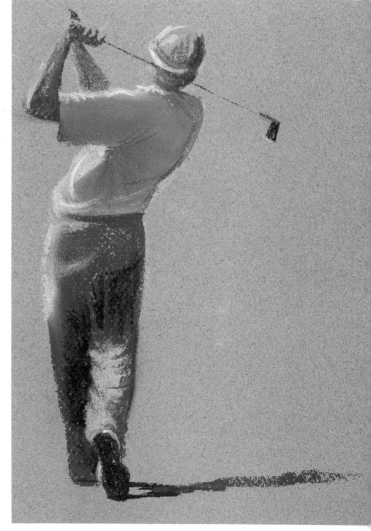

SKETCHING MOVEMENT FROM PHOTOGRAPHS

Although it is better to draw from life, rather than from photographs, circumstances sometimes make this impossible. A prime example is capturing movement in animals. You can capture a specific moment or take a sequence of movements with a camera, and work on the sketches later. On such occasions it is perfectly acceptable to use photographs as reference, but do not be tempted to copy them.

When working from photographs it is vital to keep sketches loose and free so that maximum movement (and minimum stiffness) is portrayed. I find pastel an ideal

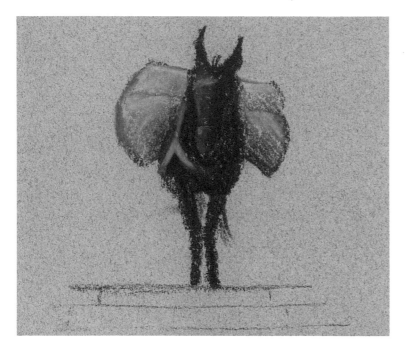

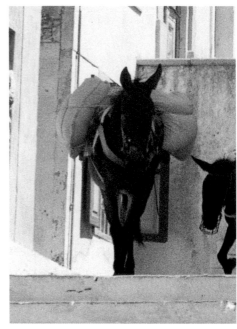

The passing donkey train in Greece clattered by too quickly to sketch, but I managed to take several photographs. I even altered the shape of the donkey's baggage to keep the effect simple and keep the focus on movement.

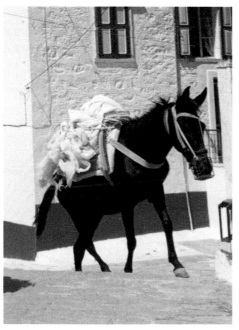

medium for this as the sketchy marks help to convey movement and discourage slavish copying from the photograph.

I use photographs for reference, simplifying and adjusting shapes to suit the impression I want to create. I use the basic shapes captured on camera and improve the tonal values to relate to the scene in which I am using them. Not all poses look convincing, but an understanding of how animals move, gleaned from constant observation, will bring eventual success. Even if your sketches are not detailed enough to place in the foreground or middle distance of a painting, they may be very useful for the backgrounds.

The stages of movement are easier to see in photographs and I was able to use them as reference for later sketches. You can add sketches taken from photographs to your sketchbook and use them when you need them.

DEMONSTRATION

SCENE WITH MOVING FIGURES AND ANIMALS: FANORE

Every time I have been to Fanore Beach in County Clare on the west coast of Ireland, it is lively with crowds of people, riders on horseback and a rich variety of bustle and life. Rather than capture anything ambitious on site, I take numerous photographs and do many sketches, including some ideas for composition, from which I can create detailed paintings later.

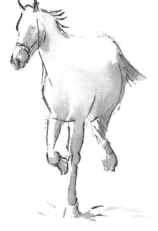

With all the photographs and the sketches done on site and ideas brewing in my head, I decide to begin with some preliminary sketches. A distant impression of horses and riders will be sufficient for the painting, but first I must practise some moving horses.

I start with a horse and rider; I could use this in the foreground, but it may be too dominant. I also try a few horses galloping along the beach, as they often do here. Next I try a few distant horses and riders, this time in watercolour (Fig 2). Although they are not ideal – the legs of some of the horses are too short – I feel more comfortable with these, and favour the pale wash of two riders, and a leader who will be slightly closer.

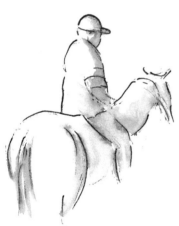

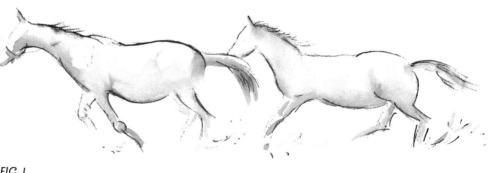

FIG 1
Preliminary horse sketches using a pen with water-soluble ink that gives instant tonal value when the line is washed with water. Although there is no detail here, the horses convey spirited movement helped by the fluidity of the rapid wash.

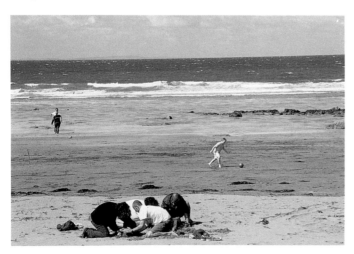

Photograph of the group taken on site and used later as reference.

FIG 2
These miniature watercolour sketches were tentatively started in raw sienna and the colour was applied later.

I also plan three main points of action going on: a foreground group of teenagers building sand castles, a distant figure with her dog paddling in the sea, and a young lad playing football.

The main group is worked out in a watercolour sketch (Fig 3). It is important to establish the outer shape of the mass of figures at the outset, as I will use the negative painting technique, painting the sand colour around the figures and leaving them unpainted so that their white T-shirts will show up against the sand.

As I paint in the shadows on the figures I discover a problem. I have carefully recorded that the light is coming in from the left, as in the photo, but find that the light looks better coming from the opposite side. When you are putting ideas together like this it is important that you establish your light source otherwise your picture will look very odd, with light coming in from all directions.

I continue with the other figures, using many of the same colours that I used in the miniature sketches to build up my main figures.

Once I have established my main characters I turn my attention to the overall composition. A pencil sketch (Fig 6) helps the plan to come together, and now it is time to put all the elements together in one painting.

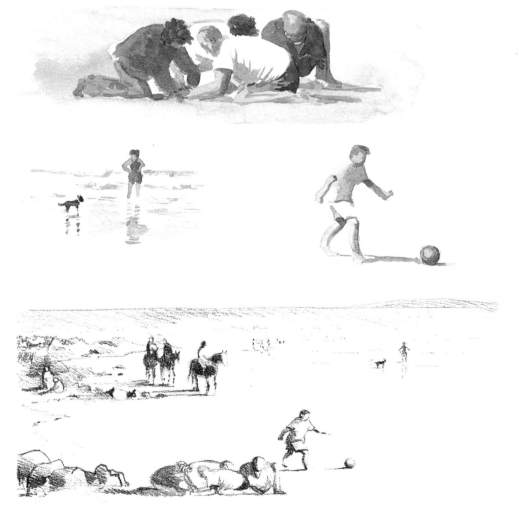

FIG 3
The shirts of the central figures are given blue shadows. For contrast, a deeper shade of blue is taken over the clothing of the others. The skin tone is diluted light red, with burnt umber shadows.

FIGS 4 AND 5
Two of the main points of action are tried out before starting on the main painting.

FIG 6
When planning your composition remember that a good lead-in takes the eye into the picture and encourages it to travel around.

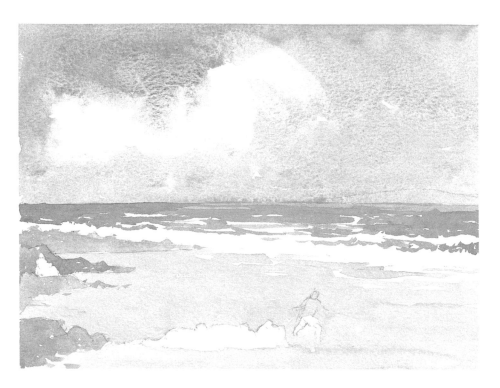

Stage I

I set out the main scene as a simple seascape, lightly positioning the main figure groups in pencil, as they have to be pre-planned, being lighter than the surrounding colour. A weak wash of raw sienna is put into the sky for cloud. While it is wet I immediately add ultramarine and allow the colours to merge. The lower part of the sky is Prussian blue.

Along the horizon the sea is a deeper Prussian blue. I leave irregular breaks of white here and there, to suggest tidal movement. As the sea comes towards the shore, the broken shapes become bigger and the blue areas smaller and more broken up. In effect, I am using negative painting to block in the wave shapes.

Adding a touch of ultramarine to the blue, I block in the rocks leaving the shape of two figures at one side. A wash of raw sienna and light red (to give a peachy tint that is very typical of the sand on this beach), is taken over the sand area. It is broken next to the waves to allow the white paper to gleam through as if it is wet.

Stage 2

The scene develops with the distant land lightly painted in blue. I deepen the sea colour with a darker wash of Prussian blue. To vary the tone, I leave breaks so that the first wash shows through. I darken the underside of the waves to accentuate the white foam. Ultramarine and light red are added to the rocks for depth of colour.

Now is the time to suggest the position of the figures. I paint them in lightly with pale raw sienna, which I can easily wipe off if I position the figures wrongly. Once the figures are in place, I deepen the skin tones with light red.

Stage 3

Starting with the distant figures, I put in the two horses and riders using light red and burnt umber in slightly stronger tones than the surrounding background. I also strengthen the distant figure and her dog and reflect them in the wet sand. Next, I add colour to the small group to the side. I define the main rider and horse with a dark mixture of burnt umber and ultramarine. I paint the main group before remembering to reverse the light source, and balance the cast shadows. Finally, I strengthen the colours where needed. This sunny day at Fanore could be developed into oils or pastels next.

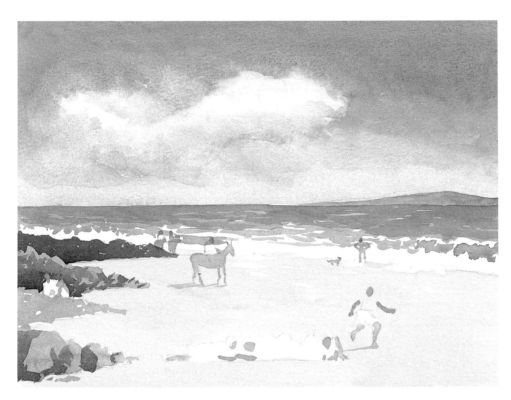

STAGE 2
Colour and tone are strengthened and figures are blocked in with pale raw sienna.

STAGE 3
Figures and animals are painted in detail and given shadows and reflections where appropriate.

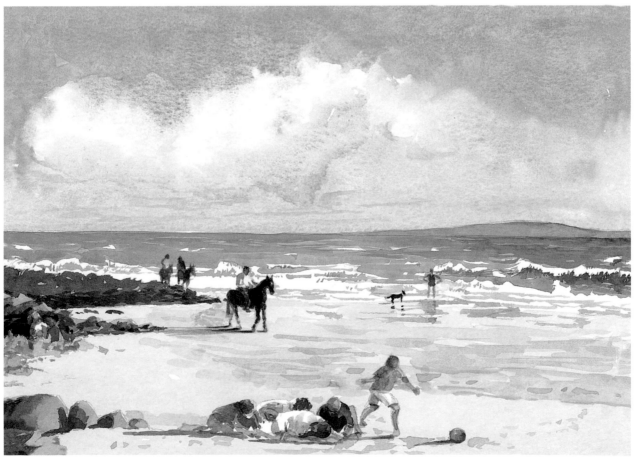

CHAPTER SIX

GROUPS & INTERACTION

AS SOON AS YOU PLACE MORE THAN ONE FIGURE OR ANIMAL IN A PAINTING, AN INTERACTION TAKES PLACE BETWEEN THEM: PEOPLE MEET AND COMMUNICATE, ANIMALS GRAZE IN HERDS. IT IS THIS INTERACTION THAT CONCERNS US IN THIS CHAPTER.

By gradually building on the simple technique of drawing stick people that you learnt in Chapter One, you can progress to some quite complex groups of figures. Start by painting two people (as Fig 1), and notice how a subtle change in the position of the legs, the angle of the arms, or the direction of the head can alter the attitude and character of the figures. Now try building up a group of four (as Fig 2). Begin with sticks and then block in the shapes with a pale colour such as raw sienna. Impromptu groups such as these can be added to areas of street scenes in need of some lively interest.

Another way to approach the introduction of groups into a painting is to see the figures as one large shape, or several abstract shapes, (Fig 3). When you are drawing from life, it is useful to block in the main shape of a group or a couple (Fig 4) quickly to capture the way figures relate, before they walk away from one another. Later, you can record details of the individual figures.

FIG 1
A walking man has been developed from a stick person. When a child is added, an exchange develops between them that suggests a reluctant child being pulled along.

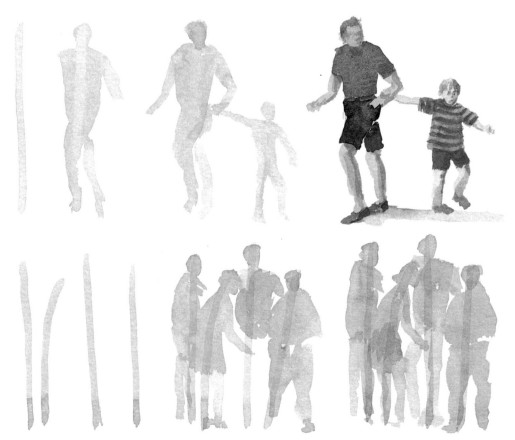

FIG 2
The four stick people suggest a group standing quite close together. Even at this early stage you can vary the angles between them. As you build them up you can overlap the figures to convey conversation between them.

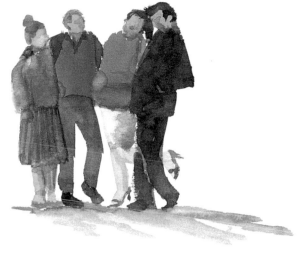

FIG 3

Splashes of colour suggest clothing, and by adding heads, legs, and an arm or two, characters emerge from this abstract group. A small movement, such as the inclined head of the figure in the pink jumper, can begin to tell a story and invite a bit of fun.

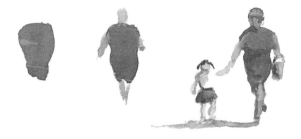

FIG 4

Distant figures can be given a similar abstract treatment to Figure 3. Here a red splash becomes a rather large lady holding her daughter by the hand.

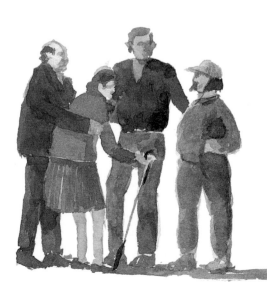

FIG 5

If sketching time is limited, as when this couple walked by, block in the overall shape of the figures with a pale wash of raw sienna watercolour. Then break the mass down into separate figures.

FIG 6

By the time colour is added to the characters in Fig 2, further details are suggested, such as a man introducing a new friend to his parents.

GETTING CLOSER TO GROUPS

Once you have made some initial sketches and filled the pages of your sketchbook with distant groups that you can use in later paintings, you can move a little closer to your group so that they become the focal point of the painting.

Although it is generally better not to make all the characters in a group equally important in case they compete, you can bend the rules a little in your first attempts to paint groups close to. If you go for compositions that give equal importance to all the characters, you will be able to concentrate on the composition and the interaction between the characters. This will enable you to place the figures in their setting to maximum advantage, and you will not have to paint any of them in the kind of detail that is intimidating.

In 'Around the Table' the three figures dominate the composition, linked by the table and the background. The composition is all about the three figures and what they are doing. Without them the subject would be uninteresting, but at the same time they are anonymous enough to need no facial details, and are certainly not portraits. Likewise, the three figures in 'Waiting for the Boat' are of equal importance and make an interesting study as they chatter together.

As you become more confident with groups you can decide which character, or group of characters, will be the focal point. This will enable you to concentrate on them and treat the rest as a supporting act. Think of it rather like a stage production – they can't all be main characters.

AROUND THE TABLE
Although the three figures in this watercolour sketch lack detail, there is no question that they are a coherent group bound together by their setting and the equal tonal value that has been given to them.

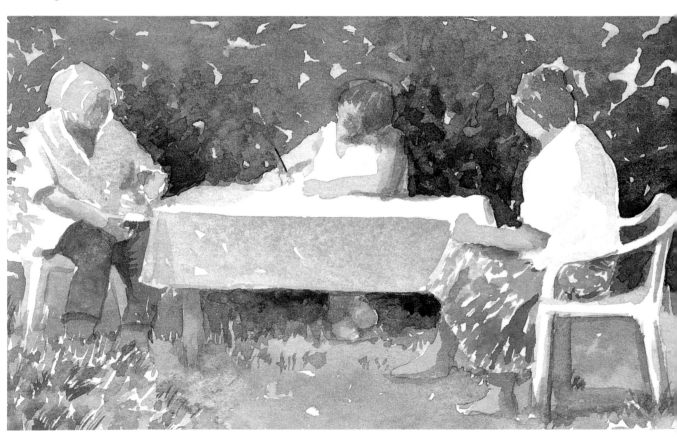

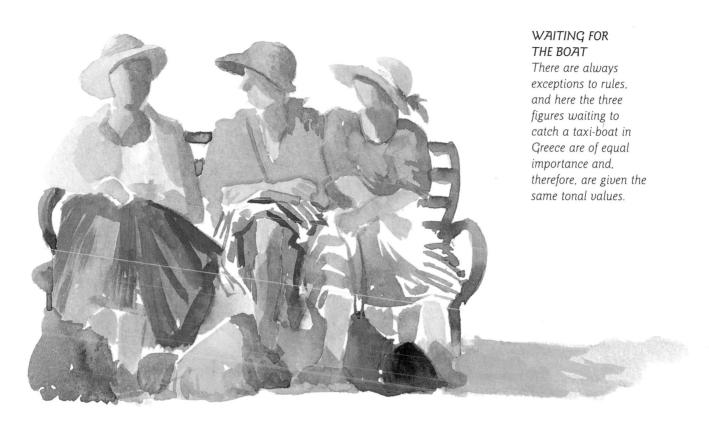

WAITING FOR THE BOAT

There are always exceptions to rules, and here the three figures waiting to catch a taxi-boat in Greece are of equal importance and, therefore, are given the same tonal values.

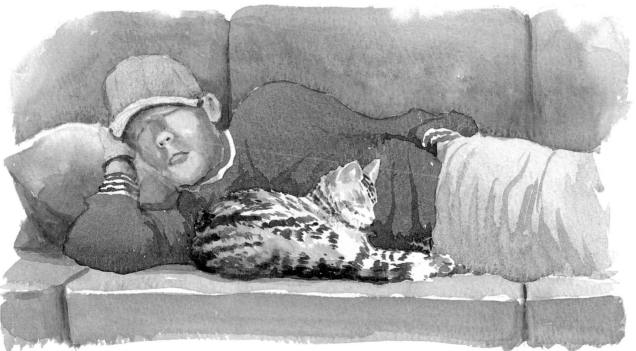

CATNAP: MATT AND THE CAT

Sometimes interaction can be static, as in this watercolour. The light on the cat's head stands out well against my son's dark jumper, yet the softer edges melt towards Matt's head creating an interaction between the two characters.

Raw sienna is an excellent skin tone for placing figures in a composition. Unlike some other colours, when wet it is an easy colour to wipe out if you want to make changes.

GROUPS WITHIN SETTINGS

Do not be intimidated into thinking that you have to get things right first time. There are many ways of breaking yourself gently into a group composition, and several tips that will help you to accomplish what seems, at first, to be impossible.

When painting groups, it is tempting to paint the people as individuals, with the result that the painting has no focal point. It is generally best to decide which characters will be the focal point and treat the others as the supporting cast. It can take several attempts to get the composition to gel, so don't be afraid to try some sketches and take some photographs from different angles. The final picture can be worked from both the sketches and photographs.

BEACH BARBECUE

At the planning stage, it's best not to go with your first attempt, but to try several options and then choose the one that works best. When I began work on the beach barbecue group the watercolour sketch was done quickly on the spot, a photograph was taken from a different angle, and the pastel study worked from both, to improve on the previous ideas.

The watercolour sketch, painted directly without drawing, was a quick attempt to capture the group of people slowly sizzling in the Greek sunshine. I positioned the heads first, the main character being the large lady in the middle, and scaled the others down around her. The same pale raw sienna wash was then continued through the bodies. I built up the poses as I went along, and occasionally wiped one out where, because the model moved, it did not work out too well.

Once I was reasonably happy with the position of the characters, I painted in the sea with a deep blue. I used negative painting, leaving spaces approximately where the parasols would be and weakened the blue towards the shore. In the foreground I deepened the colour of the golden sand with raw sienna and strengthened it with orange mixed from cadmium red and lemon yellow.

When the setting was complete I added pink and yellow parasols and then, to finish off, I put in dashes of colour to suggest clothing.

In this preliminary watercolour sketch the large woman in the centre is the focal point of the group and remained so through all versions of the composition. I painted in the group of figures first with a raw sienna wash, although their clothes were painted in last.

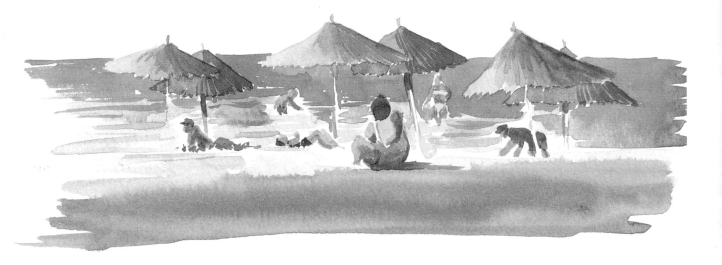

The pastel version is another stage on from the watercolour sketch. It uses a combination of ideas from the first sketch and a photograph. When you work from various sources like this, beware of the temptation to abandon your sketches and copy the photograph. In this pastel version I was keen to keep the freedom and spontaneity of the first sketch, so I concentrated on that.

For this composition I worked on a bright blue paper. Unlike the watercolour sketch, the first step in this pastel study was to block in the setting of sky, sea and sand.

Once the background was in place I turned to the figures. The main character was placed even closer to the foreground this time, with the clutter of bodies, sun beds and parasols being pushed further away towards the shore line. I positioned the bodies with portrait pink, using dots and dashes to suggest the bodies at the water's edge and in the sea. I resisted the temptation to develop them too far, using highlights and shadows where necessary, rather like the distant sheep you tackled in Chapter Two. Even bikinis and swimsuits are only suggested with dashes of bright yellow or red, to add sparkle.

BEACH BARBECUE
In this pastel study, before I positioned the figures I blocked in the setting. I began with the sky, using a pale sky blue low down and a deeper blue higher up. A strong Winsor blue defined the horizon. To create a warm contrast to the deep blue sea I used golden ochre, portrait pink, and pale raw sienna for the sand.

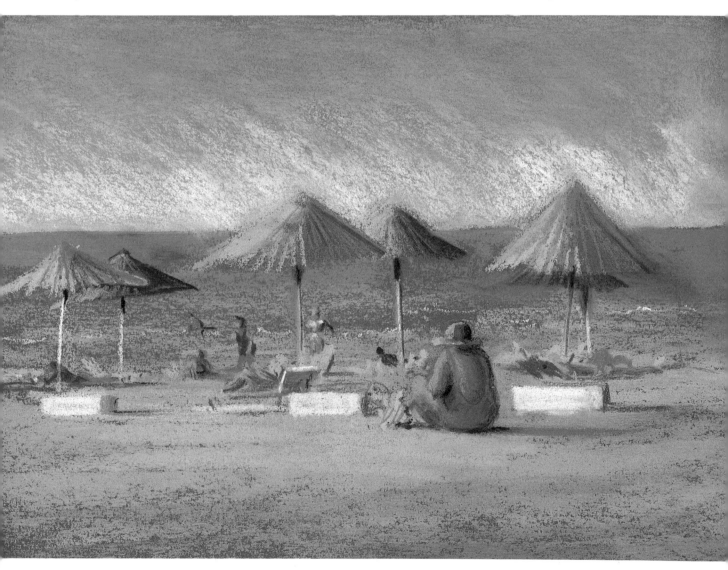

PAINTING IN THE OLIVE GROVE

In this painting we have moved closer to the figures. If you find the thought of painting figures close up intimidating, build your confidence with some pencil sketches first. You can draw the basic shapes of the figures and experiment with the direction of light and shade first from photographs, then as your confidence grows, from life.

The heat of the day and the brilliance of sunlight made the scene of painters in an olive grove a tempting subject to sketch. The strong shapes of the tree trunks and figures against the light background appealed to me, as did the great concentration shown by the three figures, sitting painting together.

The background was in itself a lovely view and might easily have become too dominant, but it was not the object of this exercise. So I kept it a pale tone throughout, with just a suggestion of pale blue-green for the hillside, and a soft pink for the Tuscan buildings, enhanced by the pale beige of the paper. I kept the vineyards in the middle distance quite pale, to help show up the figures.

TIP

When you are out sketching or taking preliminary photographs be aware that there may be several potential paintings in one scene. The background of one painting may make the subject of another, so don't miss out on ideas for more paintings.

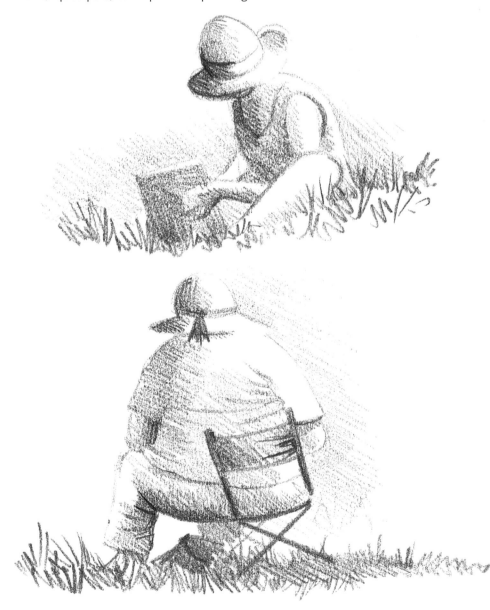

With the light coming in from the right, these preliminary sketches for 'Painting in the Olive Grove' show how the figures will look when the whole composition is put together.

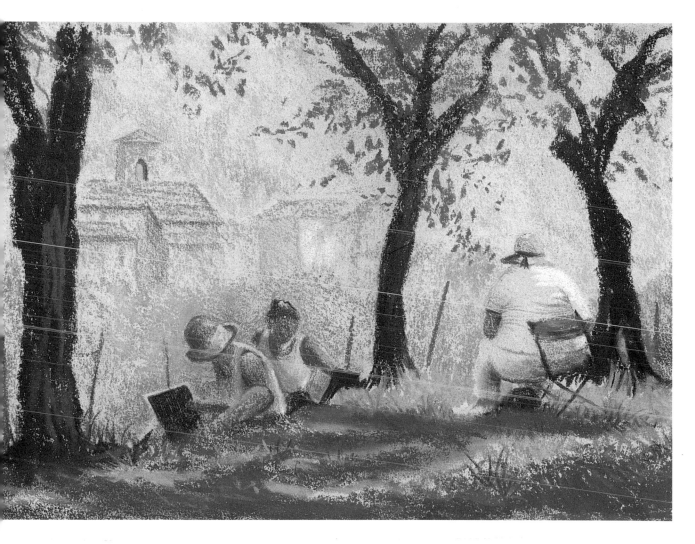

Once the background scene was set, I positioned the three main olive trees with dark brown and grey, to create the framework for the group of figures.

I thought carefully about where to place the group of two figures in this composition as they are the focal point. It is best not to give all the figures equal importance, or they will compete with each other. The dominant tone of the two figures is dark against light, although the single figure is softly silhouetted as she is sitting further out towards diffused light and shade. I have allowed her to melt slightly into the background in some places, causing what is known as 'soft' or 'lost' edges.

Using a pale skin tone of raw sienna, I placed the two figures, and then blocked in the single figure in pale blue. Once I was satisfied with the position and shapes of the figures I began to build up the colours of the clothing. To strengthen the feeling of strong light, I created plenty of contrast between the lightest and darkest tones.

The dark framework of the chair is deliberate, to make it stand out against the pale figure and the light straw colour on the ground. Other shapes, such as bags and sketchbooks, are equally dark, yet understated in detail and drawn in the same dark colours as the trees, to help link them.

PAINTING IN THE OLIVE GROVE
The little group painting under the trees creates a strong composition and the medium, pastel on pale beige paper, helps to lend more depth to the feeling of strong sunlight and deep shade.

PAVEMENT CAFE

This particular scene epitomises the impact you can achieve with counterchange (see Chapter Four) as well as showing some interaction between people and their pets. At first glance the setting may seem complicated, with pavement cafés, tables, chairs and figures to deal with. However, if you treat the overall effect simply, you can leave much to the imagination.

I chose the dark indigo paper to intensify the effect of light and shade. Wherever I added colour I considered tonal value first. If the object was in shadow I added colour lightly to blend with the paper, but if the colour caught some sunlight I applied it with bravado. So a simple minimum treatment has given maximum effect.

I began by dragging light glazes of colour over the dark indigo paper to create

The impact of this scene depended on the extreme contrasts of light and shade, which I simplified first in a black and white sketch. The strong shadow from the woman leads the eye towards the dog and creates interaction between the three characters.

different areas in the background shadows. Where the buildings were in deep shade, I allowed the indigo to show through to intensify the tone.

I positioned the tables and chairs, being careful to add colour lightly where objects were in shadow. The two figures walking from deep shadow into strong sunlight gave a marvellous opportunity for counterchange. As the sun hit their faces, arms and shoulders they were lit against a dark background.

Strong sunlight hit the parasols, spilt onto the two main characters and flooded the road. I blocked it in thickly with white first, then took it a tint or two down with a subtle all-over glazing of colour.

Lastly, I made a soft suggestion of two figures in the background, then added the dog following his master, almost lurking in the shadows.

PAVEMENT CAFÉ
A dark paper, in this case Canson Mi-Tientes indigo, was used to throw the majority of this pavement café scene into deep shadow. When pastel is applied thickly, the dark paper makes the highlights stand out with dramatic effect.

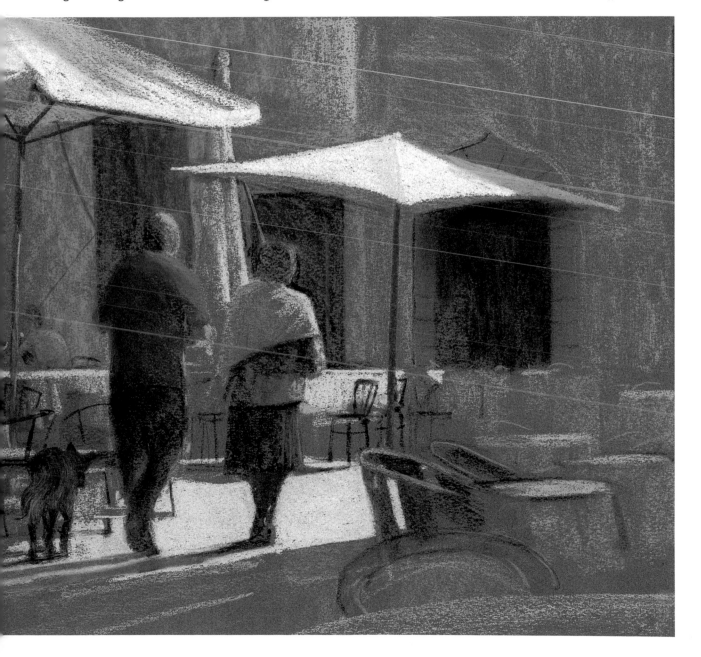

MEN IN THE PARK

You will rarely get the opportunity to record the perfect group, perfectly positioned and still for long enough to sketch, so you will have to use artistic license. When you tackle a group in a painting be prepared to invent certain amounts of interaction. If you build up individual records of people in action in your sketchbook, you can practise putting them together to see how they work as a group.

In an Italian park I came across a scene that turned into a great opportunity to record interaction between groups of people. The daily ritual of the townsmen of Montecatini in Tuscany is to meet in the park and have some serious conversation putting the world to rights before collecting the day's fresh bread and returning home.

I worked from photographs because it seemed rather intrusive to sit sketching the townsmen right under their noses. I furtively took a few snaps and then worked this study from the photographs when I got home.

I used the two photographs (above right) as my main reference. The group in the centre of the first photograph was the most prominent because the men were seated against the pale greens of the parkland. They were linked by the cars in the background to a lone seated figure who was observing another group on the left. On the right of the scene was a neat group of three seated figures who were mainly dark against the light green grass.

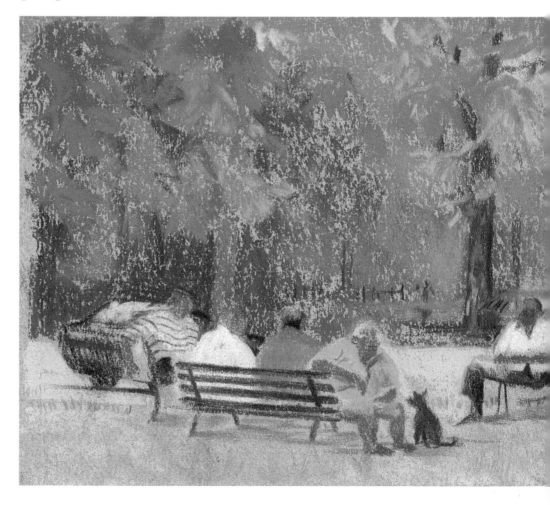

MEN IN THE PARK
Each of the three groups was lightly sketched in position with pale blue. I then blocked in the park setting before returning to the figures to build up the colours of the individuals. The central group was created to give maximum counterchange against the light, and to lead the eye through to the other groups.

When you compare the two photographs with the pastel study, you will see that I selected a few figures and groups and rejected others. I made the selection because I felt that there were too many people for one study, and I wanted to simplify the composition to get the best effect.

For example, I simplified the central group by leaving out some of the figures, but I added a standing figure to the group on the right to give it a more interesting shape. It may be that I need to try several other groupings and compositions before I get a really satisfactory result that would merit a large painting.

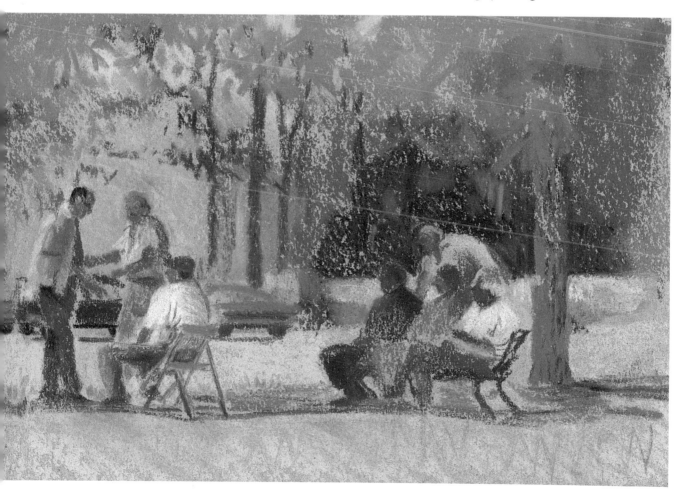

WOMEN OF THE CLOTH

A glimpse of this dramatic group as they swept from a church in Siena led me to plan this study. The tremendous interaction between the nuns is important: there is great bustle and they are all involved in each other's company. Even those in deep thought are being carried along with the main force of the group – what a dynamic subject!

The strong shapes of the nuns in their habits against the stark contrast of the steps and the entrance to the church, caught my eye as they left the church. The group disappeared in minutes so I could not sketch them on site, but I did manage to take some photographs and I worked from these to capture the moment.

I placed the figures into two main groups: a cluster to the left, and a slightly looser grouping to the right. Groups in settings need to be linked in some way to keep the composition harmonious and the eye moving through the picture. Fortunately, rather like the cars in 'Men in the Park', in this study the horizontal steps in the background link the two groups.

The almost colourless habits against the bleached building made this composition predominantly tonal. The strength of tone is the key, with dramatic contrasts in some places and softer edges in others. The dark empty doorway is also stark, although if I do more studies later, I may succumb to a figure here.

With the exception of the figures in white, I used a pale blue to block in all the figures. I added the white ones next in broad, simple strokes of the pastel, allowing one figure to merge into another in places. To create soft shadows on the white clothing I used the pale blue, but the shadows on the other figures were created with deeper blues and greys.

To keep the colours within a sympathetic spectrum I matched the darkest headwear to the dark blue-brown of the doorway. I then added the pinks for all the faces, hands and feet, and made dark brown shadows on the legs, and grey shadows on the pavement. I finished off with suggestions of facial features made with pastel pencils in colours similar to those already used.

Be selective when you plan a composition; you do not have to incorporate everything you see. Compare the photographs with the pastel study and you will see that I have cleared the tourists from the picture so that the groups of nuns are the focus in a simple and more dramatic setting.

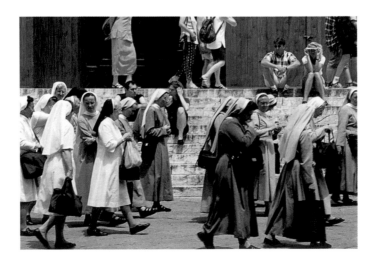

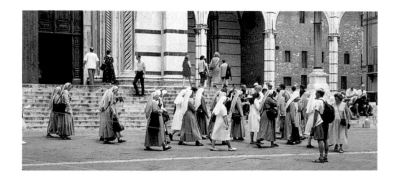

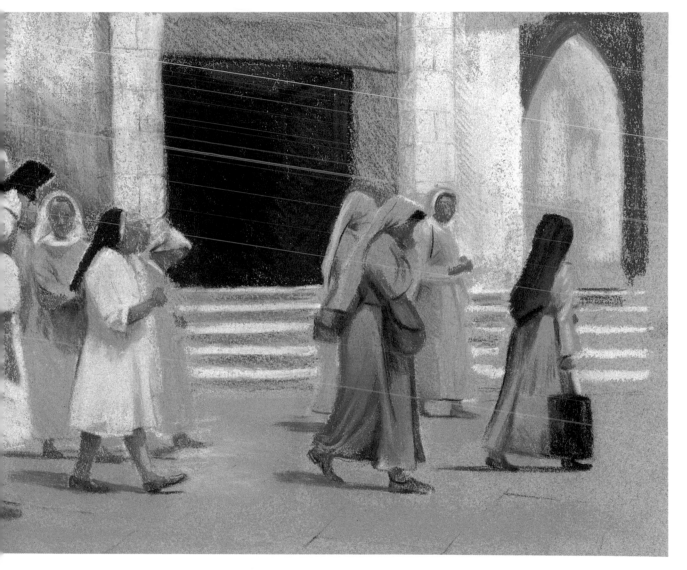

WOMEN OF THE CLOTH
The background in this pastel study of nuns in Siena is not accurate, but manipulated to suit the composition and the tonal qualities of the picture. I created a darker backdrop for the group on the left, and a lighter one for the others.

MARKET SCENE

Tackling a painting of groups of people in a complicated setting may seem beyond the reach of beginners. Let me reassure you that even the most seasoned artist may have to make several studies of one subject before the composition gels. The market scene I tackle here is an example of how it may be necessary to make more than one attempt at a composition.

A rapid pencil sketch to capture the bustle of a street market scene. Oil, watercolour or pastel paintings can develop even from rough sketches like these.

The study of the market was built up from several different sources and they weren't even made in the same country, let alone at the same time! I had a rough

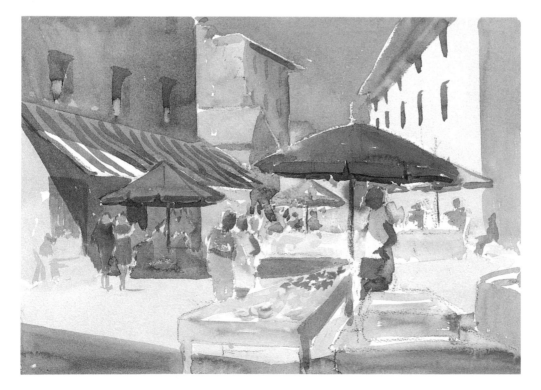

This first watercolour attempt at the market scene could probably have been developed in places, and even rescued by pastel, or pen, but I did not feel it worked properly and was already thinking of another layout.

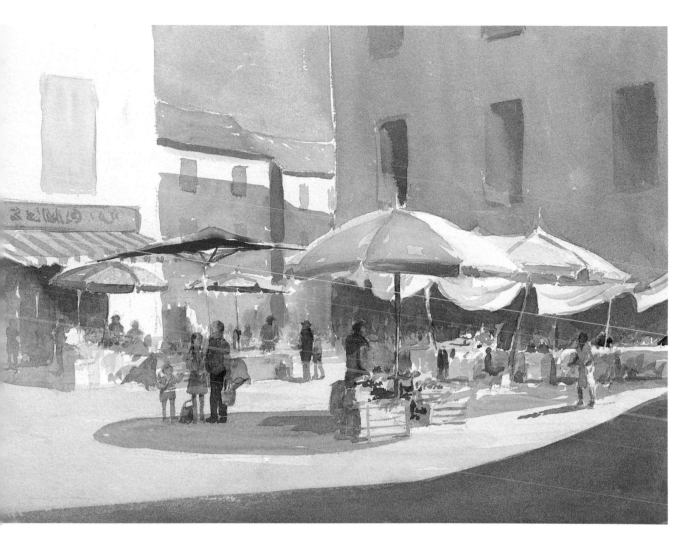

pencil sketch, in which I had tried to capture the bustle of a busy street market scene. I also had some photographs of the same street market, taken months later. I decided to try to co-ordinate some aspects of this scene with another market photographed on another trip in a different country!

The subject is a colourful one, but full of temptations to fiddle. I wanted to simplify the background buildings, which seemed too fussy, and concentrate on the colour and shapes of the umbrellas and stalls, so I planned a very loose watercolour, which I might work up in pastel or oils later.

The first watercolour sketch was an attempt to simplify the buildings, and get a general idea of the structure of the street composition, with the action in the background and a simple foreground. However, I quickly became dissatisfied with the layout and lost interest in the whole scene completely.

The final watercolour, 'Market Scene', seemed easier, and although the buildings were probably simplified too much, I was happier with the general plan and the feeling of background bustle and action. The strong, dark shadows in the foreground that attracted me in the photograph worked well, and the scene came together better. The figures at the front were added at the end as the foreground space seemed too empty.

MARKET SCENE
I was much happier with my second attempt. The composition came together in a much more satisfactory way. It may have been because I managed to keep going without interruption. I always find a watercolour painting comes together better if painted all in one go.

FIGURES AND PORTRAITS

AS YOUR CONFIDENCE GROWS, YOU CAN START TO PAINT FIGURES IN CLOSE UP. ONCE YOU HAVE MASTERED THE BASIC PROPORTIONS OF FIGURES YOU CAN MOVE ON TO PORTRAITS AND MAKE YOUR FIRST ATTEMPTS TO CAPTURE THE LIKENESS OF A SITTER.

PROPORTION

I am always reluctant to make sweeping statements about measurements of bodies as everyone is different, but if you need a general guide to get started on drawing figures, then these rough estimates will help you to make them appear more human. They are slightly more advanced than the earlier stick method and show how, as a general rule, intersections fall on certain parts of the body.

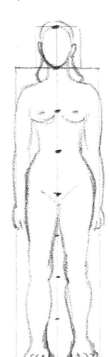

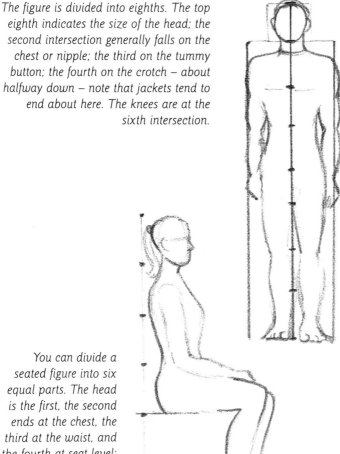

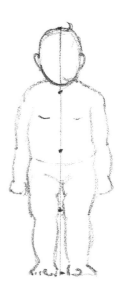

The figure is divided into eighths. The top eighth indicates the size of the head; the second intersection generally falls on the chest or nipple; the third on the tummy button; the fourth on the crotch – about halfway down – note that jackets tend to end about here. The knees are at the sixth intersection.

A female tends to be shorter than a male. In both male and female the width of the head can be contained in a square, and the width of the body can be approximately two squares wide. However, we don't all conform to these body measurements otherwise we'd all be very slim and healthy.

You can divide a seated figure into six equal parts. The head is the first, the second ends at the chest, the third at the waist, and the fourth at seat level; the fifth ends at mid calf and the sixth at the ground.

The proportions of a child's body are different from those of an adult. A baby's head is one quarter of its height. As the child grows, the proportion changes until it reaches an eighth in adulthood.

Mastering the elements of proportion takes time and practice. There are no fixed rules about the human figure, only general ones. There will always be figures that break the rules of proportion completely, like the man in the blue shirt below.

If you are tentative about painting figures close up, try painting a back view where you will not have to cope with facial features and other details. In the example below, the back view of an elderly Greek priest is set against a steep stairway, typical of the old villages. The dark-robed priest is seen against the lightest part, which projects him dramatically. The damp-on-damp technique was used to paint the robed figure, which was built up first with pale washes of violet, then with layers of stronger washes, adding each just before the previous one dried.

Although the figure in the boat is also a back view, I gave it a different treatment from the priest. I used negative painting to silhouette the figure against the water and left white highlights on the figure and boat. The dark side of the figure is in strong contrast to the light, where the white paper shines through for highlights.

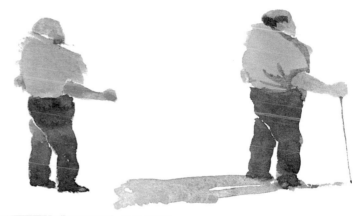

Some figures, as you can see from this character in my sketchbook, defy the rules of proportion. This man in the park in Montecatini, Italy, made a rather dazzling splash of turquoise in his summer shirt.

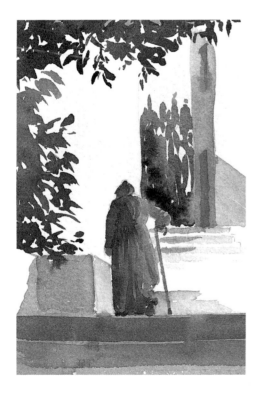

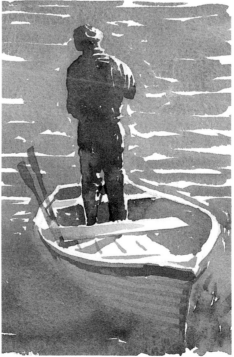

FAR LEFT
A weak wash of cadmium red to create the pink light was the starting point. When dry, I added the steps with washes of ultramarine and light red, with a touch of Winsor violet – a useful colour for shadows in hot climates.

LEFT
I wanted a strong sense of dark and light so I used negative painting, taking blue and green around the shape of the man and the boat. This left white areas where the strongest sunlight fell.

MIXING SKIN COLOURS

WATERCOLOUR MIXES

Everyone's skin colour is different and can change with reflected light from surroundings or clothing. It's best to keep colour mixes simple when blocking in a figure, and even more so when doing a portrait.

You can use various diluted tints from your palette in the light red (Fig 1) to cadmium red (Fig 3) range, but the mixture I most frequently use is one of light red and raw sienna (Fig 4). It gives a good base to work from. If you wish to build up the strength of the colour, you can repeat it.

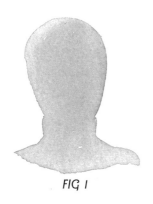

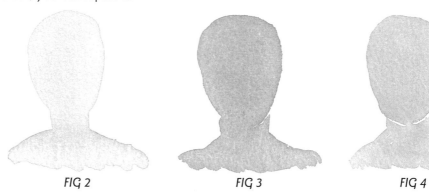

FIG 1 FIG 2 FIG 3 FIG 4

ADDING SHADOWS

The same mixture of light red and raw sienna can be laid on top again to add shadows (Fig 5). If you add blue to this, it creates a shadow with a cool colour (Fig 6), which complements the warm flesh colours. Depending on the surroundings and the colours being used to paint the surroundings, you can add green (Fig 7) made from ultramarine and lemon yellow to create depth of tone, and/or Winsor violet (Fig 8).

FIG 5 FIG 6 FIG 7 FIG 8

PASTEL MIXES

Pastel mixes for skin colours are also varied. They are also affected by the colour of paper that you use: the same pastels used on different colours will give very different results, particularly if you leave parts of the paper showing through. I often choose paper for portraits in colours that contrast with skin colours: warm skin colours go well on green, grey or blue papers. However, do not be afraid to experiment as even black paper can have a very striking effect, especially against red hair.

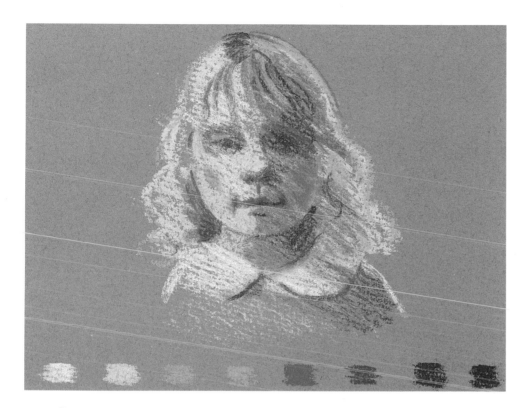

The different effects of colour and texture also add variation to pastel work. In this portrait of a child on grey paper, the flesh tint is not one colour but built up with layers of pale pinks and pale yellow ochres.

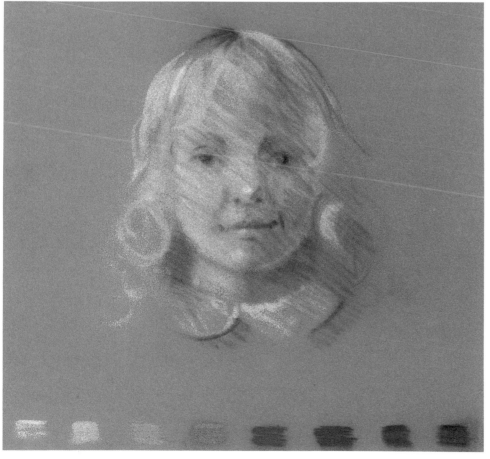

I used exactly the same pastel colours to build up the skin tones, but this time I worked on green velvet card, with a quite different effect.

GETTING CLOSER TO THE SITTER

You are now ready to be bold and to face the sitter close to. You can continue to develop your pastel or watercolour techniques while avoiding too much detail. The following studies show how to use the background to project the subject.

In Fig 1, the top half of the figure relaxing in the sun with a cigarette is projected by a background of strong dark green, which also accentuates the pose. The lower half of the figure is surrounded with light green, which helps to develop the counterchange with the darker shadows on the legs and the framework of the chair.

Another loose sketch (Fig 2) but this time in pastel, uses a dark blue background. The shadows, therefore, are only lightly developed, while the strong areas of sunlight are applied with much thicker, stronger marks.

The figure engrossed in painting (Fig 3) is the next stage on from the back-view sketches on page 95. It has no portrait details and is rather anonymous but has captured a little movement.

FIG 1
The darker washes of the skin tones were added just before the first wash was dry, creating a soft edge. The face was understated to avoid too much portrait detail, which would detract from the pose itself.

FIG 2
To encourage you to attempt a similar sketch to this one the details have been omitted and the whole study kept loose and without detail.

FIG 3
A figure engrossed in an activity is the perfect model to practise on. The subject may look up and scowl at you, but at least she is sufficiently engrossed to stay in the same pose until you finish.

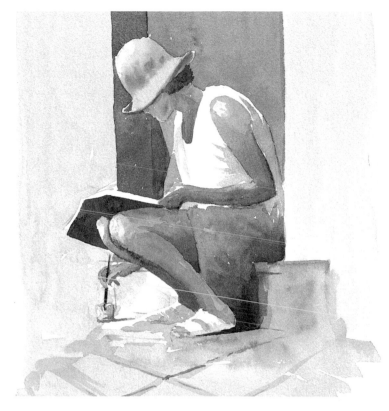

If you don't feel ready to tackle a portrait it is still possible to keep anonymity even when you are close to the sitter. Here the lack of facial features helps the viewer to focus on what the subject is doing.

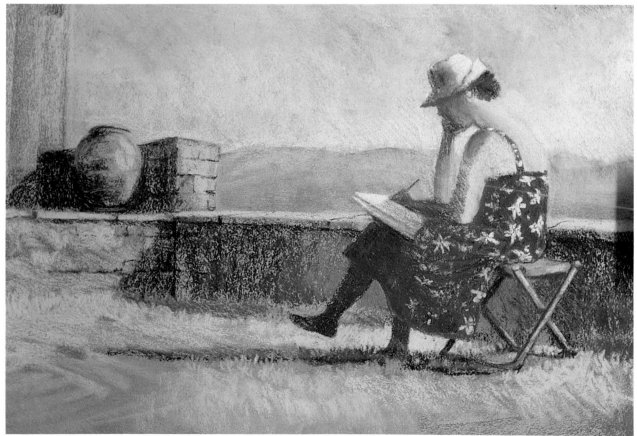

CREATING A SIMPLE HEAD FROM AN OVAL SHAPE

Simple exercises to help develop an understanding of the human head can start with a basic geometric shape – the oval. Naturally, these simplified formulas have to be regarded as a means to learn the rudimentary steps, but after much practise you will gain confidence and be able to tackle head studies without the need for the basic steps. Of course, every character is different, but the first objective is to help you to make faces look human, after which you can concentrate on capturing a likeness. Note that each feature is not drawn with lines, but built up with shadows and highlights.

Stage 1

Start with an oval. The top represents the top of the skull and the bottom the chin area. Draw a line across the oval at approximately the halfway mark: this gives you the position of the eye sockets. Halfway down again, another line gives an approximate area of the shadow under the nose. Halfway between the nose and the chin is the centre of the mouth, i.e. the gap between the lips.

Stage 2

To create a three-dimensional effect, shade down one side of the oval. Always keep the direction of the light in mind. Add the shadow of the eye sockets. It narrows slightly between the eyes, as this is the area above the bridge of the nose. Next, put in the shadow under the nose. At the mouth line, add a slightly curved line, darker at each end, to indicate the mouth. At this stage it is useful to suggest the shape of the hairstyle. If seen, the ears usually fall between the top and bottom lines.

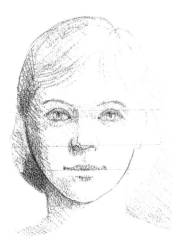

Stage 3

Build up the hair first as it helps to visualise the person, then add the eyebrows, noting their shape and thickness. Leave a gap below the eyebrows for the fleshy part of the brow. Suggest the eyeball shape, making it slightly oval to fit into the space, then develop the eye shape (see page 102) with a top lid of an appropriate depth.

A shadow leads down the side of the nose (on the side away from the light), and links with the shadow under the nose. Next develop the end of the nose and add nostrils (see page 102). Shade in the small indentation between the nose and mouth. The upper lip is shaded because it turns inward; a shadow underneath the lower lip is sufficient to show how it projects and catches the light.

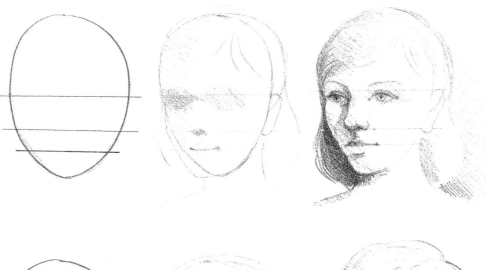

THREE-QUARTER VIEW
The same stages of development work to create a three-quarter pose. Begin with an oval and extend it for the chin and the back of the head. The nose is slightly easier this time, as you can create the shape with a line.

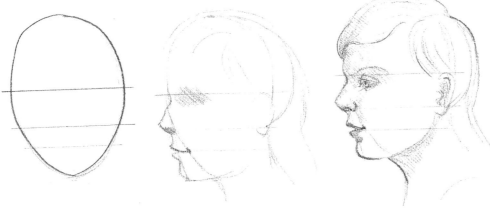

PROFILE
Develop a profile using the same measurements and treatment, but remember to develop the oval outwards for the chin and the back of the head.

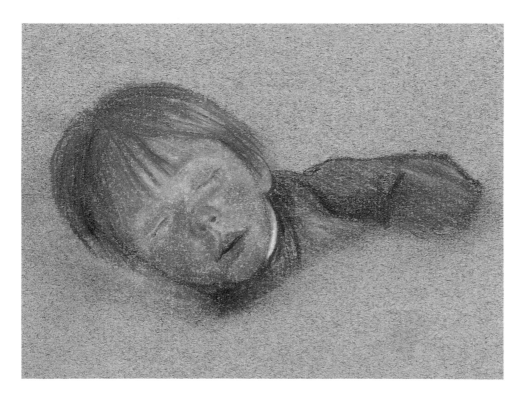

A familiar face, especially if the person is asleep, is a good model for the beginner to sketch. I often sketched my children – this is Matt – in those rare moments when they took a nap.

THE FEATURES

THE EYES

When drawing the eye, it is helpful to think of the shape of the eyeball itself. The ball creates the structure around which the skin is stretched to form the lids. When drawing a face in profile, the eye is seen from the side. This changes the angle, so the iris and pupil are seen as a foreshortened circle.

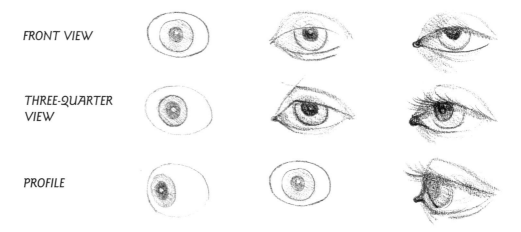

FRONT VIEW

THREE-QUARTER VIEW

PROFILE

THE NOSE

The nose is most difficult to draw from the front, as it has no line to give shape and relies only on tonal variations. In three-quarter view and in profile, the line of the projection can show specific bumps or curves that give the nose character. Remember the fleshy round part at the end of the nose; some are more pronounced than others; but they give some bulk and shape.

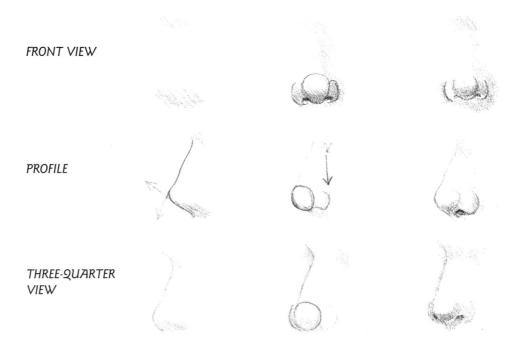

FRONT VIEW

PROFILE

THREE-QUARTER VIEW

THE MOUTH

Avoid a hard line around both lips as it makes the mouth look as if it is painted on. The lower lip protrudes and catches light and is, therefore, the lightest part. You can create the lower lip by shading where there is an indentation, just below it. In profile, the shadow falls under the nose, on the top lip and below the bottom lip.

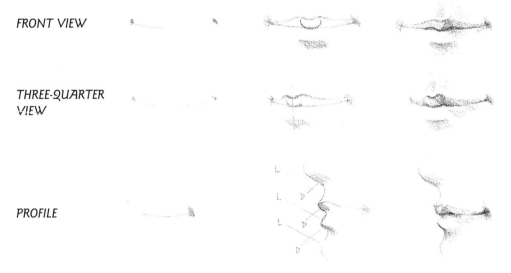

FRONT VIEW

THREE-QUARTER VIEW

PROFILE

CHANGING EXPRESSIONS

Try to avoid giving features the same expression all the time. Look carefully at the examples shown here and notice how expressions change the shape of features. The best way to understand the way these changes of shape create changes of expression is to study your own face closely in the mirror, and practise by pulling faces!

EYES

SURPRISED

If the eyes in your portraits always look surprised, it is because you are allowing too much pupil to show. Try closing the eye by making the top lid come halfway down the pupil, which will make the eye appear more relaxed, or even sleepy.

WORRIED

To create a worried expression, pull the end of the eyebrow, the inside corner of the eye and the lid upwards.

MOUTHS

DOWNWARD
A downward curve of the mouth can denote displeasure.

SLIGHTLY OPEN OR SMILING
When you want to try a slightly open or smiling mouth, understate the teeth by shading them. This avoids too much detail and prevents the teeth from protruding too much.

PORTRAITS OF MELISSA

When you try a portrait for the first time, it will make your task easier (and so help to build your confidence) if you start with a familiar face. Members of the family or a close friend are both excellent choices for a first portrait – although be warned that they can also be your most severe critics!

You can work from photographs too, and this will definitely help your confidence as a photograph can't criticise. However, you should not spend too much time working from photographs as it is most important to work from life whenever possible, even if you can only manage quick sketches.

Sleeping babies and husbands are also handy as models and they have the additional bonus of not continually asking if you have finished yet.

Over the years I have captured my daughter, Melissa, on numerous occasions, and although she has become a more reluctant sitter as she has grown up, it has been a unique way of recording her progress through life.

MELISSA AGED FOUR
This early portrait of Melissa shows very soft pastels used in a broad, blocking style without too much detail. Notice that the size of a young child's eyes can be exaggerated a little to reinforce the impact of youth.

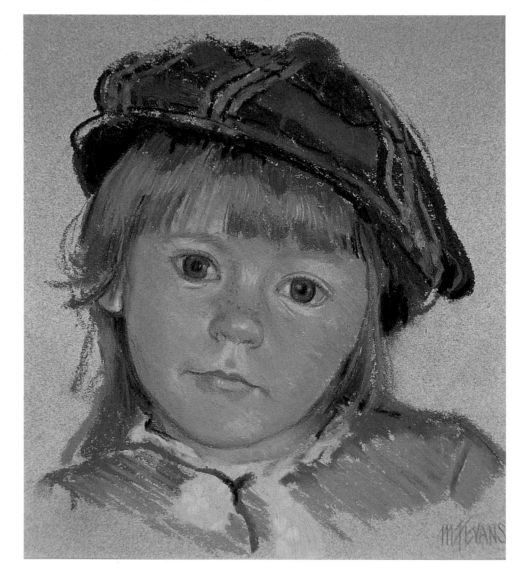

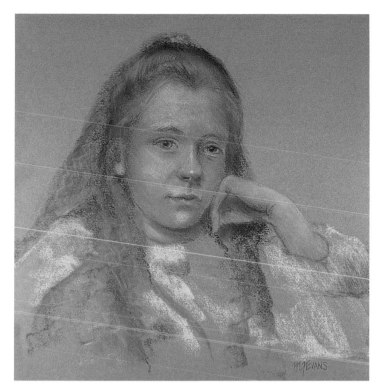

MELISSA AGED 11
Hard pastels can be just as delicate as soft pastels and were ideal to capture Melissa as a young girl. The face and the hair are painted in detail, and to concentrate the viewer's attention on the face, the clothes and ends of the hair are treated in a looser manner.

MELISSA AGED 13
As your family sitters grow older, they may be persuaded to dress up for the occasion, making the whole experience a bit more fun. This portrait of the teenage Melissa was a first attempt at loosening the style and avoiding too much detail in the features.

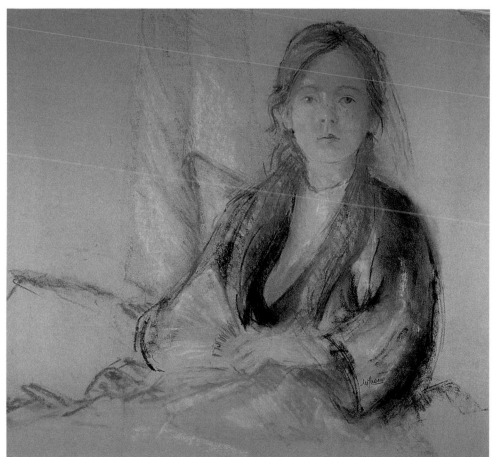

DEMONSTRATION

PORTRAIT OF MELISSA

The likeness of the sitter should grow with the portrait. At each stage, do not be afraid to rub out and start again if the likeness is not coming. The more you observe face colours, the more you realise there are greens and blues in portraits, as well as peaches and creams.

Stage 1

I chose to use mid-blue pastel paper for its cool complementary colour against the warm skin tones (see page 97). It is important to make the head a comfortable size to work into for portrait details. If it is too small, it can be very fiddly to add detail, but as a rule, it should never be larger than life size.

STAGE 1

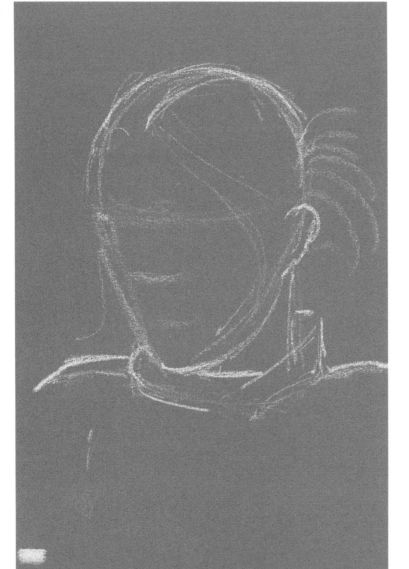

Starting with the basic oval format (see page 100) helps to determine the size of head in relation to the picture area. It allows me to see how much space there is around the portrait, which is particularly useful if I am planning to make changes such as lengthening the pose and including the shoulders, changing the head angle, adding background, or deepening the neckline.

I then adapt the head angle to suit the pose – in this case, the head is tilted forwards slightly to show more of the crown of the head and the angle of the shoulder lines. This tilt helps to add 'attitude' to the pose (especially as the model is a teenager). It is amazing how quickly a simple adjustment like this can give you the start of the character of your sitter, even before the face has any recognisable features. I can already see Melissa's head shape within this beginning; if I couldn't, it would be important to rub out and start again.

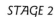

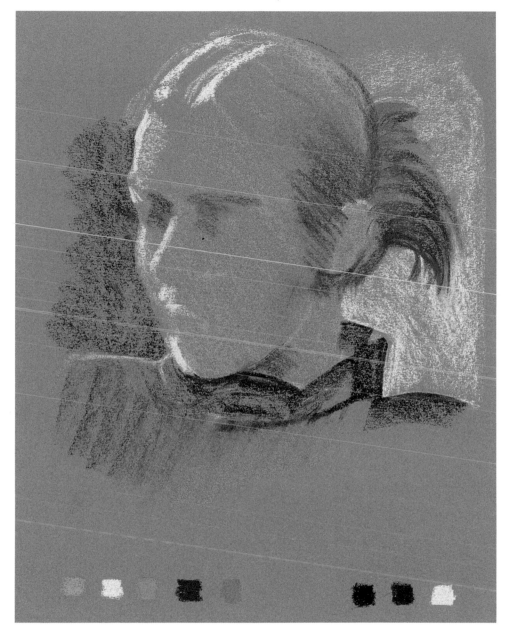

TIP

This counterchange technique is often used in portraiture to create a sense of depth around the head; light against the shadow side of the head, and dark against the light side (see Chapter Four).

Stage 2

Using a basic mixture of skin colours (see pages 96 and 97), I start to block in the colour areas, but no features at this stage. Blocking in helps to identify the main tonal plan of the composition, including the way the tone of the background relates to each side of the head. I particularly want to light up the head from behind, to show strong contrasts against Melissa's striking red hair.

I block in the colour of her jumper using some of the colours already in the portrait to keep a link going. The skin tones are adjusted to suit my sitter and can start off with basic skin tones, such as portrait pink, beige and tan, but none are ever absolutely right on their own, as complexions vary so much. Lighting and clothing can also affect skin colour. I often use a soft green to help calm these hot portrait tints.

STAGE 3

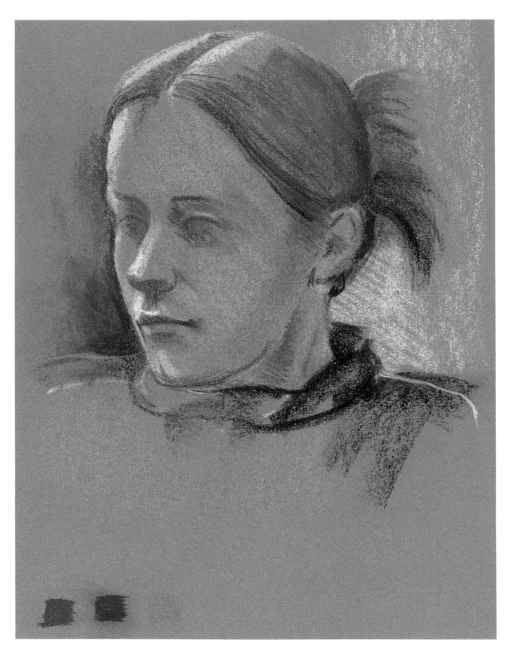

TIP

At each stage, it is important to leave the portrait at a point when you are pleased with it. You should always stop at an exciting stage – never when you are despairing. It is better to rub out and leave a blank rather than face a problem on your return.

Stage 3

Throughout the early stages of a portrait, the likeness should be developing gradually, even without fully developed features. Don't wait for the likeness to appear, as if by magic, at the end: it must grow with the portrait. So, if you lose the likeness on the way, don't be afraid to rub out and try again. A portrait may look more like the sitter before you paint the face, than afterwards when you have worked it to death!

At this stage I build up the skin tones again, keeping a balance of coolness in the face by retaining some of the blue paper. As I develop the features, I adjust the profile either with skin colours, or by negative painting (see Chapter Four), cutting into the profile with the background colour. This technique defines and highlights the profile and adds depth to the portrait at the same time.

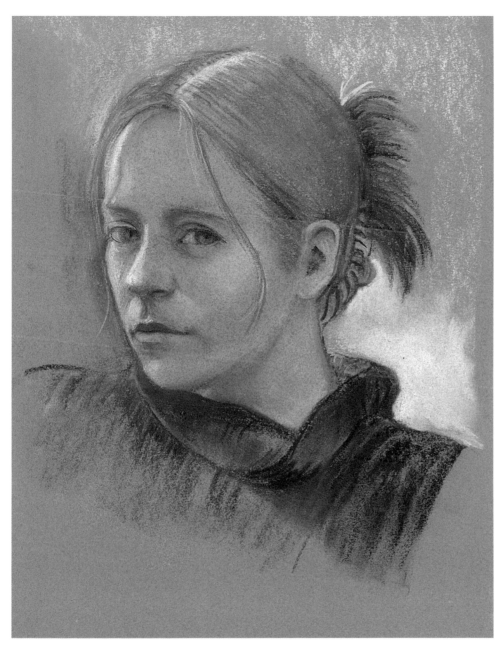

Stage 4

This is the most critical stage. I now keep moving around the portrait, working on all the features simultaneously and building them up gradually. It is important not to try to complete one feature before the rest of the face is developed, as the whole portrait must work together. There is no point in having perfect eyes, nose and mouth if they are in the wrong position and don't work together; so I work on them all in tandem, and watch how they work in relation to each other.

I also intensify the light behind the head to accentuate the hair. Melissa is now almost glaring at me, anxious for me to finish. This is a good point to give the sitter a break to relieve the tension before completing the expression. I am eager to cheer her up by raising the corners of the mouth slightly. Then I quit while I am ahead.

ANIMAL CLOSE-UPS

GETTING CLOSER TO YOUR ANIMAL SUBJECTS MEANS GETTING TO GRIPS WITH THE TEXTURE OF FUR AND FEATHERS, BUT NOT NECESSARILY PRODUCING AN EXACT LIKENESS OF YOUR PET.

TEXTURES

When you get up close to an animal you need to consider texture. Rendering fur and feathers is one of the more challenging aspects of painting animals, but if you scrutinise your subject and follow some basic principles it need not be difficult.

FUR
There are two different types of fur: close to the body the fur is soft and fine, while the outer layer is made up of coarse guard hairs. An animal's hair grows in particular directions, so it is important to observe the direction of growth and paint it in the direction it grows.

When painting fur, whatever the medium, it's the layers of colours that count. The underfur is painted in first as a block of colour. Then the tonal variations are added in darker or lighter shades. The outer layers are built up with fine brush strokes, using a dry-ish brush and several different colours.

If you choose pastels, break off a third of the stick and use the side to block in the underfur. Once the lights and shades are in place use the fine edge of the stick to create the top coat. A slightly hard pastel builds the texture of fur well. Never bother to sharpen your pastels – it's such a waste.

PASTEL CAT
A snoozing pet presents a great opportunity to draw fur from life. In this rapid pastel sketch I concentrated on the head, noting that the hair on a cat's face grows back from the nose. I built up the texture in layers before the sleeper woke.

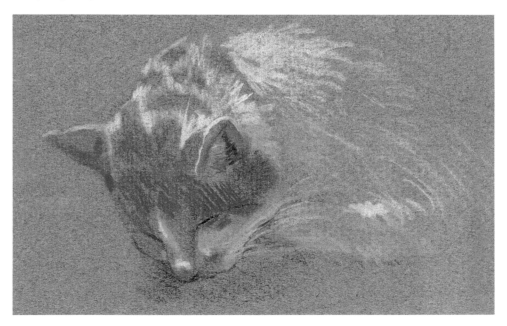

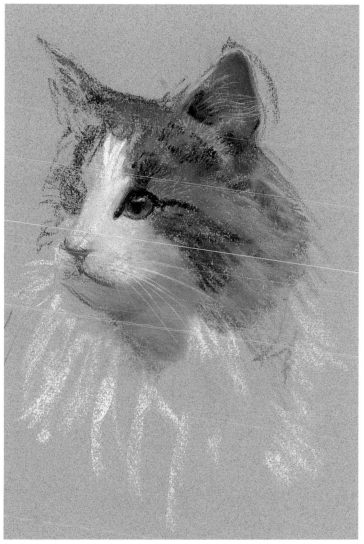

UNFINISHED CAT'S HEAD

The right-hand side of the cat's face is more highly finished than the left to show the build up of texture. The left-hand side of the face is unfinished to show the underpainting. I sketched in the outline of the cat's head with a soft brown pastel, which you can still see around the ears. I then used a warm ochre (which is still exposed around the ears) to block in the underfur. Over this I added quick impressions of the colouring and general direction of the markings on the face, before putting in the eyes and whiskers.

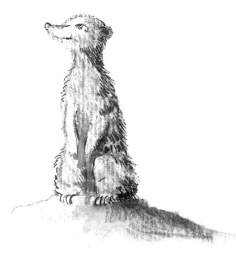

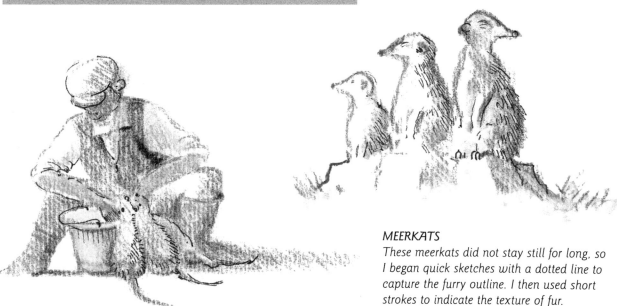

MEERKATS

These meerkats did not stay still for long, so I began quick sketches with a dotted line to capture the furry outline. I then used short strokes to indicate the texture of fur.

To create texture in oils I use the same multi-layered approach as I do for water-colour. I began this oil sketch of a cat by sketching in the cat's shape with a blue-grey mixture. Where the cat's body was in shadow the white fur had a blue tinge, so I blocked in all but the whitest areas with a half-tone mixture of ultramarine and white. The dark markings of the cat were subdued, with lost edges in places. I blocked them in with burnt umber and olive green. The final touches were to add a few pink tinges to the white areas, and a light gold to give a warm glow to the texture of the fur.

TURKISH CAT
I had previously painted this Turkish cat in pastel and thought it would be interesting to try an oil sketch using the brush marks to represent the texture of the fur.

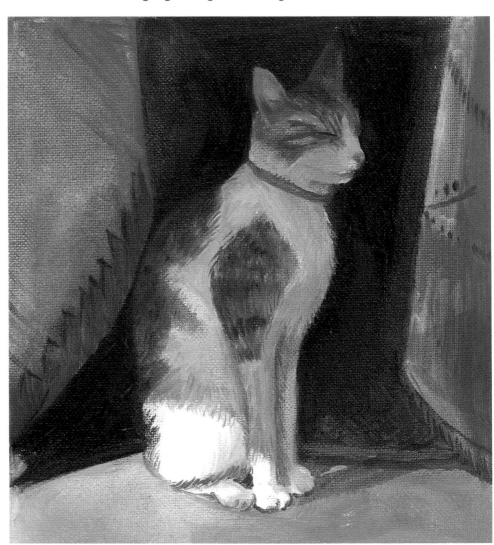

The feathers of the buzzard were built up in layers with a range of watercolour washes. The outer feathers were built up in the same way, but a dark wash around each feather created shadow.

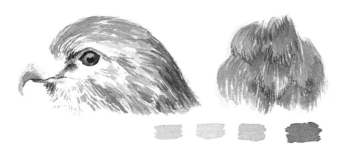

FEATHERS

When painting feathers, methods similar to those used for creating fur apply: the texture is built up in layers of colours. The fine downy feathers close to the body can be blocked in with a single colour, after which you can add the tonal variations. The outer feathers are added in appropriate colours on top of the first two layers.

In the watercolour study of a buzzard's head, it was important to resist the temptation to start on the texture of

the feathers immediately, but to look underneath to the base colour. On a light pencil drawing, a dilution of raw sienna was applied over most of the head. Once dry, a wash of light red was applied in broken strokes, following the direction of the feathers, and leaving some of the original colour showing. A third wash of blue-grey was added in a similar way, and also used to develop the eye and beak. Finally a more neutral grey mixed from ultramarine and burnt umber was added to the eye to make a stronger dark.

Sometimes, a less detailed subject presents itself. I chanced on these two wild doves in Viareggio, Italy, and immediately wanted to paint them in watercolour. I began by sketching in the branches and the doves lightly in pencil, planning to leave the foliage loose and almost out of focus. Leaving two or three patches unpainted for the strongest highlights, I took a pale pink wash over both branches and birds. Once the foliage was in place and the branches made darker, I had a strong setting for the doves whose light shapes were beginning to show up well. I strengthened the doves with pink, deepening to mauve shadows. Details, such as the eyes and beaks, were next, but more important were the ruffled feathers on the foreground bird. I painted these feathers with a size 10 round brush using darker tones of ultramarine and light red. I used a line to separate each feather but diluted the edge to soften the effect.

VIAREGGIO DOVES
I wanted the effect of two birds partly camouflaged among the foliage, so I had to resist painting the doves feather by feather. Although there is less detail than in the buzzard, the effect is unmistakably feathery.

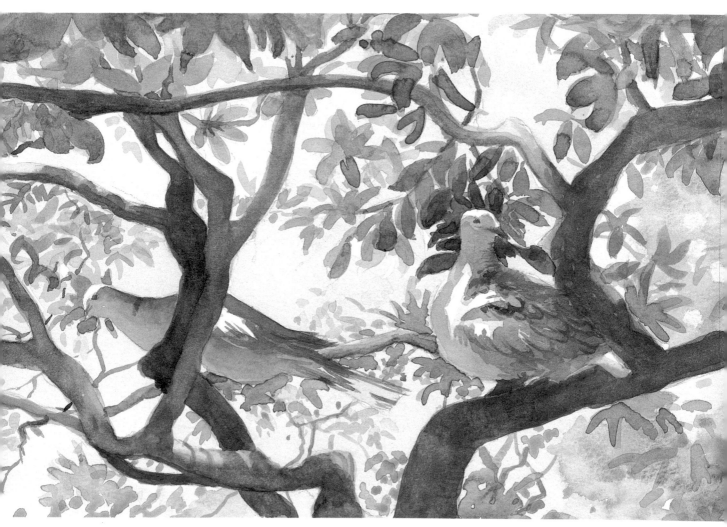

TIP

When working in oils, I use an old sable-mixture brush to add paint over an area of wet paint, allowing the new paint to glide over the underpainting without lifting it off.

TOM

If you look beyond the vibrant oranges and reds in Tom's ginger coat, the main body colour is pale and creamy. This was blocked in first and the strong colours added on top. Making layers of colour like this gives depth and helps to suggest the texture of fur.

OIL SKETCHES

Oil paint is a fluid and forgiving medium. Oils have the qualities of many other mediums combined, such as the fluidity of watercolour (without running out of control), and the versatility of pastel, which stays where you put it yet can be blended easily.

Unfortunately, beginners often have preconceived ideas about the medium; they perceive oils as formal and feel obliged to produce a 'finished' painting, often working it to death in the process. This reverent attitude means that they may lose the great opportunity to sketch with this wonderfully versatile and obliging medium.

I was once told that to keep a dog's interest long enough to paint its face well, you should work with a sliver of raw meat on your shoulder. Not only will the dog keep still but continue to gaze lovingly at you! I don't know if it works as I've never fancied a piece of steak slowly rotting near my nose. Animals are beguiling subjects, but to capture a pose you have to work very quickly, so oil sketches suit the subject very well. You can make a quick sketch from life with oil pastel, which is fluid and mobile and will rub out easily with a turps-dampened rag. You can also take some photographs for reference.

Armed with your rapid life sketch and photographs you can begin an oil sketch. I use a size 6 filbert bristle brush to sketch the outline shape first. Then I use a very diluted wash of paint to block in the body colour. This base colour is kept very simple and I resist the temptation to build up fur or texture too soon. At this stage I put in the shadow areas in the correct tones to give depth.

I used this fast and simple style in the following demonstration and oil sketches of my pets to show you how I tackle such tempting yet frustrating subjects.

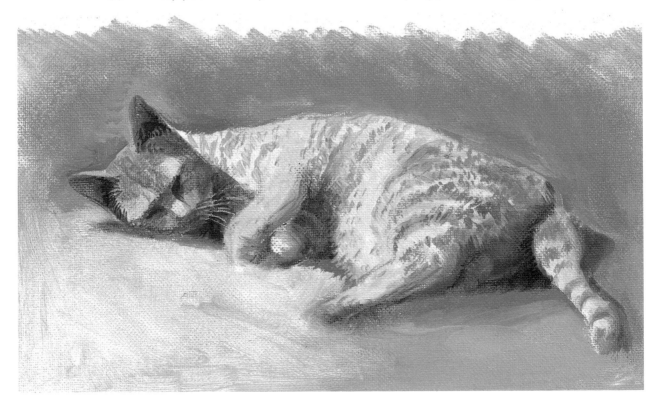

DEMONSTRATION

THE STAGES OF AN OIL SKETCH: HEAD OF A CAT

I have used a five-stage approach to make an oil sketch of the head of my cat Trixie.
Have a go, and see how you get on.

STAGE 1

Stage 1

Using a thin wash of burnt umber or raw sienna oil paint and a bristle brush, I simplified the head of our tabby cat, Trixie, to a circular shape. I then added the shape of her muzzle, which made it more feline. Two triangular shapes mark the position of her ears. An early indication of the height of the neck was useful at this stage too.

STAGE 2

Stage 2

The background was blocked in next, using burnt umber and raw sienna mixed with white. I applied the paint thinly at first, just to show up the shape of the profile and indicated the position of the eyes and nose. Although the outline could be altered as the portrait developed, I was quite careful to achieve a reasonable likeness of the cat at this early stage.

STAGE 3

Stage 3

Trixie's base colour was blocked in next. At this stage, it is important to resist the temptation to add all the lovely top colours in her coat. They must be added at a later stage so that the coat acquires depth of colour. The base fur is quite a strong ginger colour, so I used a strong yellow ochre base for this, knowing that certain areas will show in the finished sketch. I blocked in the remaining white areas with a pale ultramarine. To strengthen the likeness, I also reshaped her face where necessary, using the base colour.

STAGE 4

Stage 4

To strengthen the tonal depth and variation I added shadows of an ultramarine and light red mix on the cat's ears, on the top and at the back of her head, and down the side of her nose. Using a slightly darker version of the previous colour mix, I also added the cast shadow that projects her head forwards from the background.

Stage 5

By now, I was eager to add her features, and the fun began. Using softer brushes to help the paint glide over the underpainting, I added the browns and grey-blue tints of ultramarine and burnt umber over the ochre base. I also added tints of light red to redden the coat. These colours were added using short, thin strokes in the direction of growth and built up in layers to create the furry texture of a short-haired cat. As this texture continued to the outer edges of the body I used the same technique to break the outline with the short strokes, again giving a furry effect. Finally, I created the whiskers by scratching the paint off with a palette knife. Now she really looks like Trixie, even if it is only a sketch!

STAGE 5

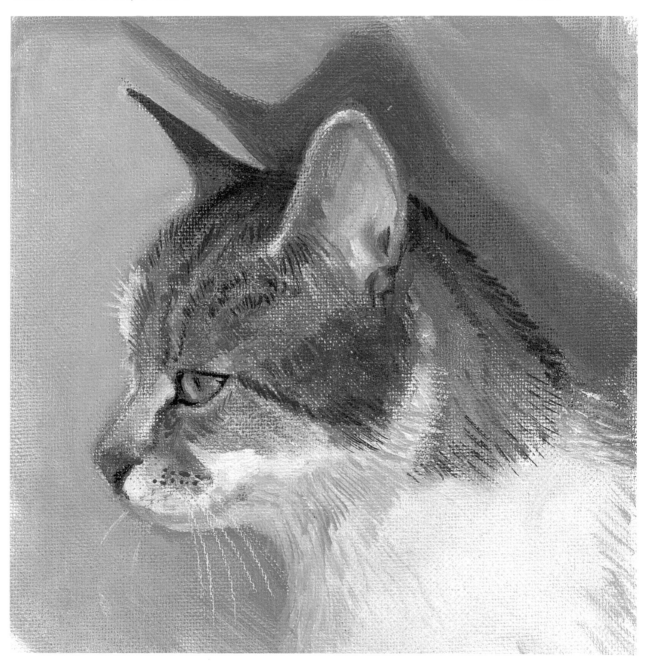

BARNEY

Dogs and cats love to curl up, creating an oval shape that relates to the geometric shapes in Chapter One. Our Yorkshire terrier, Barney, often curls up in the studio and I have frequently sketched him in this pose.

Working in oils, I begin by sketching his shape in a thin wash of blue-grey. With the pose quickly established, I start to block in the body with a pale cream colour. Once the blocking in is complete I work on the background. I block in around the body with ultramarine and white, and mix a soft green for the cushion.

Next I add the lights and darks to the body and background, which helps to produce an effect of depth. To give counterchange, I make Barney's back darker than the background and his head lighter.

The layers of paint are still thinly applied, but with a softer brush to avoid moving the previous layer of paint. These layers help to create the thickness of Barney's coat. To build up texture, I apply the brush strokes in the direction that the hair grows.

As the structure and formation of Barney's coat emerge I highlight it with lighter tints, and contrast these with darker tones. I continuously work around the whole body, adding extra depth where needed. To pull the composition together, I use some of the background colours on Barney's coat. Long before he realises what's happening, a rapid but evocative sketch of Barney appears.

In this oil sketch of my dog, Barney, I did not thicken the paint on the second application as I would in an oil painting. At this stage, oils often lose their freshness and spontaneity because thick paint is easily overworked and becomes murky.

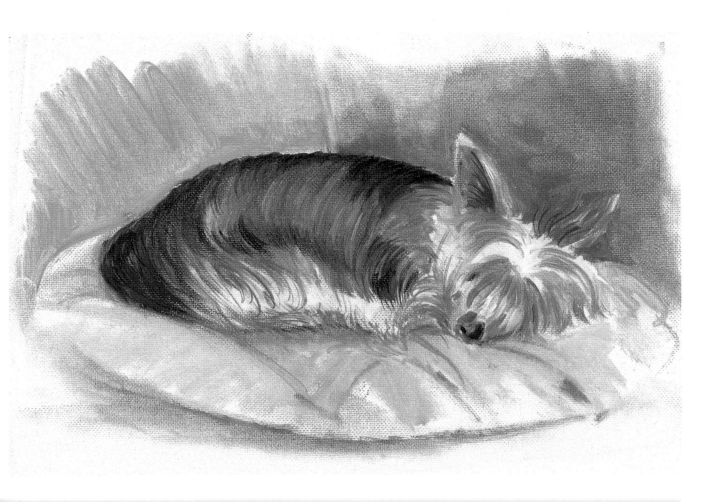

KELSAE

Kelsae, a friend's sweet-natured Border terrier, would never sit still for a portrait, but does not mind a camera. When I cannot work entirely from life, and have to use photographs as reference, I find oil sketches a good medium as they look natural and spontaneous, as if captured from life. Of course, I know Kelsae and am familiar with the way she moves and behaves, which helps to bring life to the sketch. If you have never met the animal you are to paint, it is almost impossible to capture a sparkling likeness from a photograph alone.

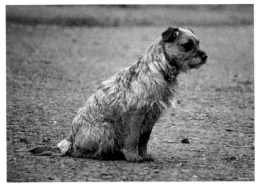

Kelsae's pose is that of a loyal little dog waiting for her mistress. She has a slight lurch forward as if ready to pounce. Again, I half close my eyes and look for the geometric shape in the animal's pose. I see Kelsae's pose as a triangle.

Once the shape is established I sketch it onto a sheet of real canvas paper (available at all good art suppliers) with a light grey wash. Next, I surround the dog's shape with a background colour: this time I use a transparent raw sienna wash, adding ultramarine and light red with white at the darkest points. To vary the tone, I make it dark against Kelsae's light back, and light around her head and front, to set off her profile.

The terrier's body varies in colour from pale blond and rich rust to the typical Border terrier colouring of a wiry grey overcoat. My plan is to block in the warm body colour with yellow ochre and white, then add the elderly grey coat she has grown on top. The ultramarine and light red mixture used in the background is ideal for the wiry coat, and links the subject with the background. After the top coat, I add highlights and shadows using a soft brush to give a wispy finish to the texture of her rough coat. As this is a sketch and not a full painting I am careful not to overwork it. I want to keep the style loose and give the sketch a feeling of spontaneity.

You can't expect animals to sit still while they have their portrait done, even if it is only a sketch. Photographs are a helpful reference, but to make a really good portrait, it is essential to work from life.

TIP

Don't spend more than an hour on an oil sketch like these, and less time if possible. Too much time means you may be tempted to overwork the sketch and risk losing spontaneity and looseness.

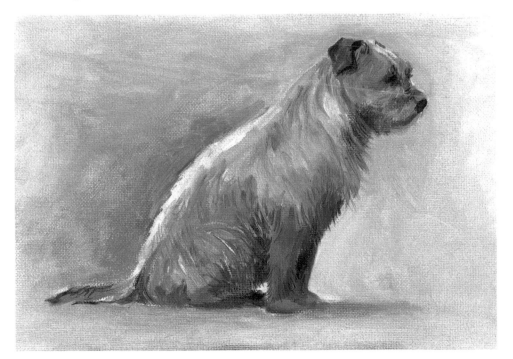

The texture of the canvas shows through in places in this oil sketch of Kelsae, adding to the textural depth of the painting. For oil sketches I use sheets of real canvas rather than stretched canvases, as they are more convenient.

DEMONSTRATION

OIL STUDY OF AN ANIMAL: GOLDEN RETRIEVER

Dogs do not sit for an artist, but some good photographs supplemented with quick sketches in pencil or pastel will help you understand the dog's basic anatomy. The knowledge you build up from watching animals and sketching them as they move will help you to achieve better portraits.

STAGE 1
At this stage the drawing is kept to a minimum with no detail

Stage 1

Using water-mixable oil paints (see page 127) I wipe a thin solution of burnt umber over a sheet of white canvas paper with kitchen roll. This takes away the starkness of the surface. Continuing with a weak tint of burnt umber, I sketch in the basic outline of the dog and its surroundings with a size 6 bristle brush. Any mistakes in the composition can easily be wiped off at this stage with a rag.

STAGE 2
Areas of light and dark are blocked in at this stage. The colour theme of the painting is brown and gold with some green.

TIP

To maintain harmony in an oil portrait, select a limited colour theme and stick to it.

Stage 2

To ensure that the composition is balanced, strong contrasts of tone must be established now. I maintain my policy of no detail, and establish the main shapes first using a large flat brush and mixtures of burnt umber and titanium white, simplifying the tonal areas into light, medium and dark. This broad, simple approach helps to develop the subject and is similar to the techniques used by the Old Masters to underpaint entirely in a range of tones of one colour, over which the final colours are added. The overall plan of the painting is easy to recognise now. You can change things radically if you are not happy with the development as the whole painting will still wipe off.

STAGE 3
I used raw sienna and touches of cadmium red as a base for the dog's coat. The dominant browns of the background were broken up with dark green, Prussian blue and burnt umber.

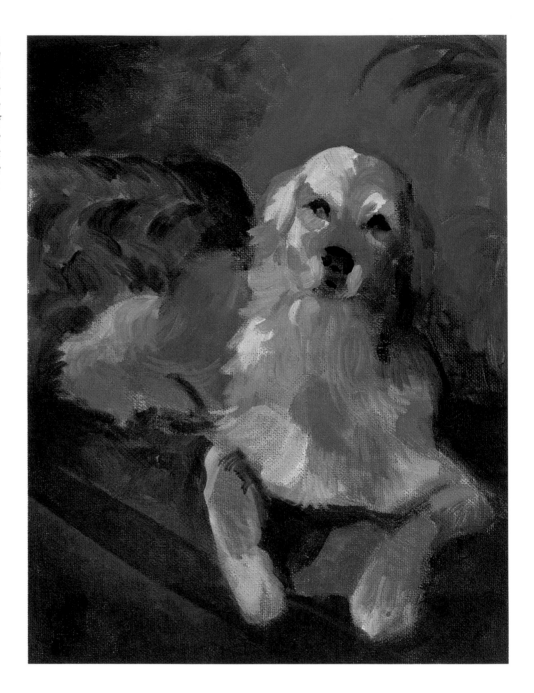

Stage 3

I am now ready to consider likeness and detail. If you tackle these too early composition and balance will suffer, and tonal depth will not develop soon enough. The large simple shape of the dog can be blocked in with thicker paint. Remember, this is the base colour on which the fur will be developed. I block in the shape of the dog, dividing it into areas of light, medium and dark.

The background is blocked in with a similar consistency of paint. Next, I work on the head carefully dividing the face into features. I avoid detail by using a large brush. I also begin to suggest the texture of the dog's body fur using size 10 and 6 filbert brushes and small brush strokes in the direction of the growth.

Then back to the face. My reward for holding back on detail is to develop the features positioning the eye and the dark area around it. Once the nose and mouth are in position I add some more highlights to the head.

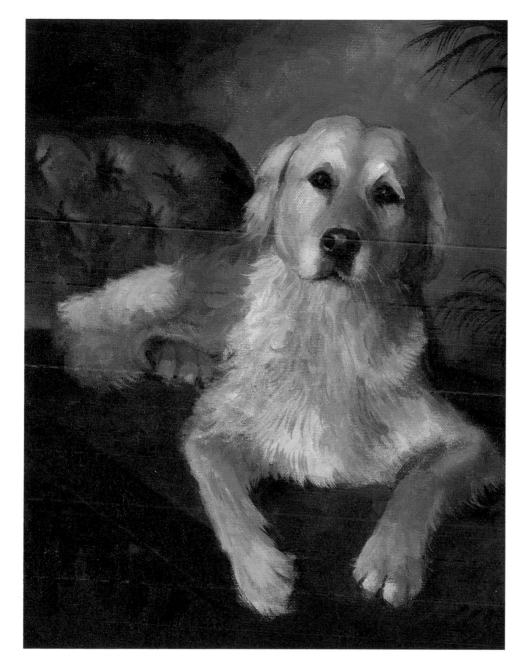

I like to build up to a crescendo with the detail and therefore I prefer to complete the background first. It must project the image and keep the mood atmospheric, so I intensify the colour behind the head darkening it softly towards the corners.

Stage 4

This is the exciting stage. Although I do not want the portrait to lose its painterly qualities the features must be accurate so I check their proportions and position again. Then I work into the eye area, highlighting the pupil, but merging the outer edge with the dark surround to maintain the softness of the expression.

To create the smooth facial fur I blend the highlights with a soft brush or a finger. To break up the smooth base coat of the chest area I make brush strokes in the direction of the wisps of fur. I add shadows but no detail to the front paws because the face is the focal point of the painting.

MATERIALS

SELECTING THE APPROPRIATE MATERIALS FOR A PROJECT WILL GIVE
YOU A FLYING START TOWARDS SUCCESS. HERE IS A SELECTION OF
MATERIALS THAT I HAVE FOUND GOOD FOR BOTH BEGINNERS AND
MORE EXPERIENCED ARTISTS TO USE.

SKETCHBOOK

Choose a sketchbook with good-quality watercolour paper of 300gsm (140lb) mini-
mum, so that it will not cockle when you apply a watercolour wash. The surface of the
paper should be slightly textured – a 'Not' paper is a good choice as it is not too rough
and not too smooth. I recommend size A4 as the page will take several small sketches,
or a landscape. If you want a small sketchbook that will slip into your pocket an A6 is
perfect, although you will probably only get one sketch per page.

PENCILS

Soft pencils are essential. My 'desert island' pencil is a 2B, but you can use softer pen-
cils up to 6B and it is useful to have a selection.

WATERCOLOUR MATERIALS

PAPER

It is always worth experimenting with different types of papers, but don't economise too much, a heavier weight of paper is best.

Watercolour paper is known by its weight. The paper is measured in grams per square metre (gsm). The heaviest papers are the thickest, and the thicker the paper the less it will cockle when you apply a wash. A good-quality paper is usually about 300gsm (140lb) in weight. This weight of paper should not cockle during the exercises in this book.

Watercolour paper has different surface textures. Rough textures are best left to the most experienced watercolourists, At the other end of the scale, smooth papers (hot pressed) have no tooth to hold the paint and are most used for detailed work, such as architectural and botanical paintings. Between these two is cold pressed paper or 'Not' paper (not hot pressed), which has a medium surface, ideal for beginners.

I have used Lana Watercolour paper with a Not surface, Saunders Waterford paper, or Cotman paper for most of the watercolours in the book.

PAINTS
The limited palette of watercolours that I recommend is: lemon yellow, raw sienna, burnt umber, alizarin crimson, light red, French ultramarine, and Prussian or Winsor blue.

I usually use tubes of paint (rather than pans, or cakes) as they stay soft and are easier to use more freely. Student quality paints are perfect for beginners.

BRUSHES
Buy the best brushes you can afford: sable is the most expensive, but those with a mixture of sable and synthetic hairs are good, and synthetic brushes are available too.

For the exercises in this book you will need about four round brushes – sizes 16, 12, 10, and 8. You will also need a size 3 rigger. Riggers are fine, pointed brushes.

PEN AND WASH

I have used two kinds of fibre-tip pen throughout the book: those with water-soluble ink that can be washed with water to diffuse the line, and those with waterproof ink, which can't.

WATER-SOLUBLE
Edding 1800 Drawliner, sizes 0.1, 0.3, 0.5, and 0.7
Swan Stabilo Point 88, size 0.4 fine available in different coloured inks
Pilot Hi-Tecpoint V5, size extra fine
Staedtler Lumocolour.

WATERPROOF
Edding 1800 Profipen sizes 0.1, 0.3, 0.5, and 0.7
Staedtler in black and sepia.

When choosing paint, keep to a limited palette at first (see page 26), adding extra colours as the need arises. Beginners can start with student ranges, such as Winsor and Newton's Cotman range, but can convert to artists' quality-paints, which contain more pigment, later.

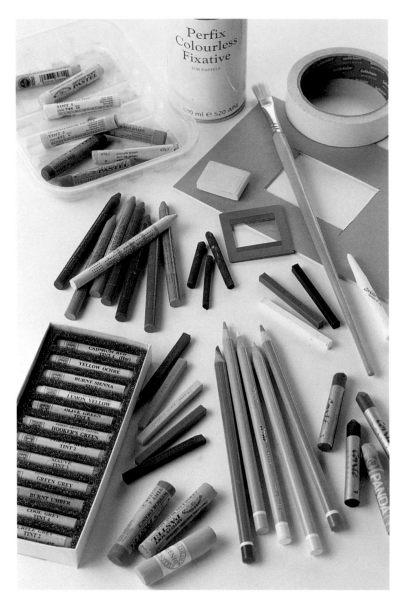

PASTEL MATERIALS

There are several different types of pastels. Soft pastels are chalky and come in sticks. Winsor & Newton produce a lovely range of very soft pastels. Slightly lightly harder is the classic Conté Carrés range, which is excellent for detailed work, such as adding figures and animals to landscapes.

If, like me, you mix soft pastels with hard it would not be too indulgent to have both groups (see page 30). I also use pastel pencils. These are especially useful for adding detail to paintings as they can be easier to manage than pastel sticks.

PASTEL PAPER

Pastel papers come in a range of colours and textures. In addition to Lana pastel paper, I use Canson Mi-Tientes pastel paper. It is a good quality paper in excellent colours and has the advantage of being double-sided, one smoother than the other.

Pastels and pastel papers come in a huge range of colours. The colour of the paper has a significant impact on the effect of the painting (see pages 56-59 and page 97).

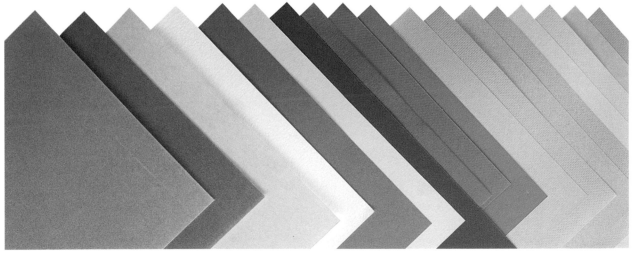

OIL PAINTING MATERIALS

PAINTS

The oil sketches in Chapter Eight were done with artists' quality oil paints thinned with pure turpentine. Artists' quality paints are the top of the range because they contain more pigment than those of student quality. Buy the best that you can afford, although it is perfectly good enough to start with student quality.

The demonstrations in Chapters Four and Eight were done with water-mixable oil paints – a great invention as they mix with water, not turpentine.

The basic palette of oil paints (see page 29) that I use is: titanium white, lemon yellow, raw sienna, burnt umber, light red, alizarin crimson, French ultramarine and Prussian blue.

MIXING

With traditional oil paints I use a tear-off paper palette and thin my paints with pure turpentine. When using water-mixable oil paints I prefer a traditional palette to mix on. This does not buckle when water is added and wipes clean. In addition to diluting the paint with water, I also use a water-mixable oil fast-drying medium, which helps when building up thicker paint.

SURFACES

To save having to stretch and prepare canvases I use real canvas boards, or sheets of real canvas paper. They can be on the expensive side, but the amount of time and frustration saved is well worth the extra expense.

BRUSHES

I use bristle brushes for laying on colour. These are available in a selection of shapes. I find that I most frequently use rounds, flats and filberts (a flat brush with rounded edges) in sizes 4, 6, 8, 10, 12 and 16, as well as a size 3 Prolene long-handled rigger. When I want to over-paint a section I use old watercolour brushes with soft sable-synthetic hair, as I find they glide over the previously applied paint well.

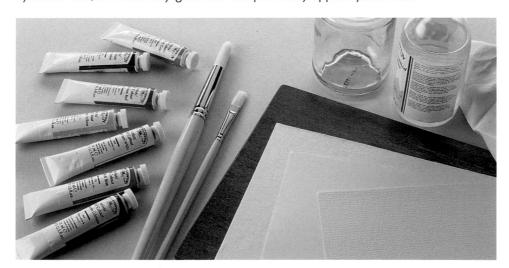

You do not need a large amount of materials for oil painting – a small selection of well-chosen colours, two or three brushes, a palette, turpentine, and ready-prepared canvas boards or sheets.

INDEX